To The Dogs

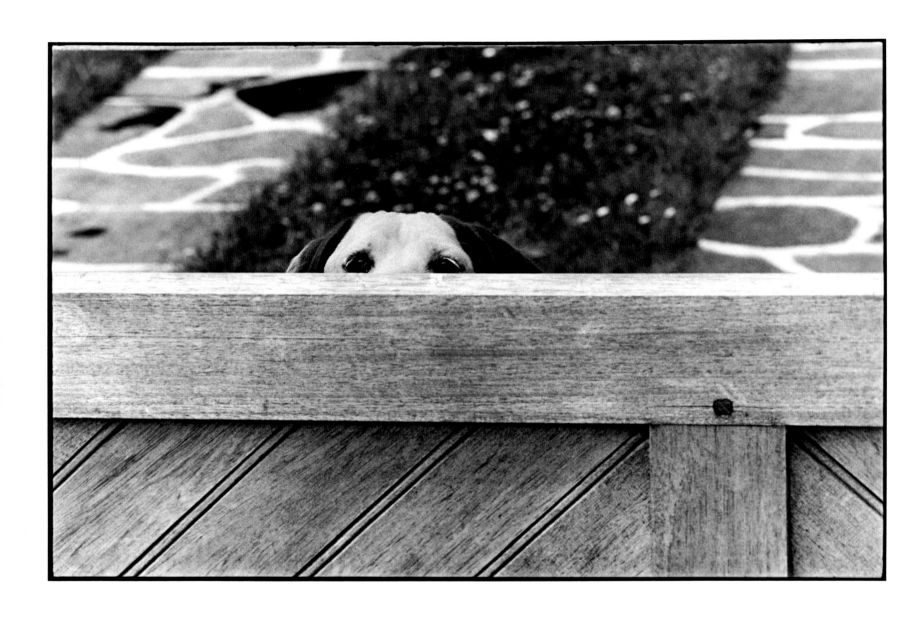

Trouville, France, 1965

Elliott Erwitt | To The Dogs

D.A.P./SCALO, New York

Elliott Erwitt: To The Dogs
Copyright © 1992 by Elliott Erwitt/Magnum Photos

All Rights Reserved under International and Pan American Copyright Conventions. No part of this
book may be reproduced in any manner without the prior written permission of the copyright holder.
First published by JICC (Japan Independent Communications Corporation).

First English language hardcover edition published by D.A.P./SCALO, 1992. Inquiries to the
publishers should be addressed to D.A.P., 636 Broadway, 12th Floor, New York, New York 10012.
Translation rights arranged with JICC, Tokyo, through Nippon Shuppan Hanbai, Tokyo.
Distributed worldwide by D.A.P/Distributed Art Publishers. Tel: (212) 473-5119 Fax: (212) 673-2887

ISBN 1-881616-01-0 (Hbk)

Designed by Katy Homans
Coordinated by Tomiyasu Shiraiwa
Edited by Akihiko Miyanaga
Printed and bound in Japan

. . . with thanks to Katy Homans, Charles Flowers, and Douglas Rice
for their dogged work on this book.
Except for the picture on page 13, none of the photographs in this book have been
electronically altered or manipulated.

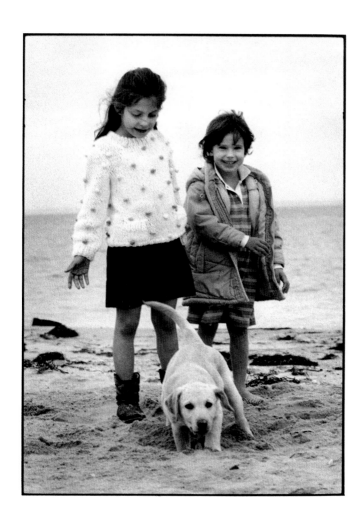

For Sasha, Amy, and Maggie and
for all the furry friends they might have had.

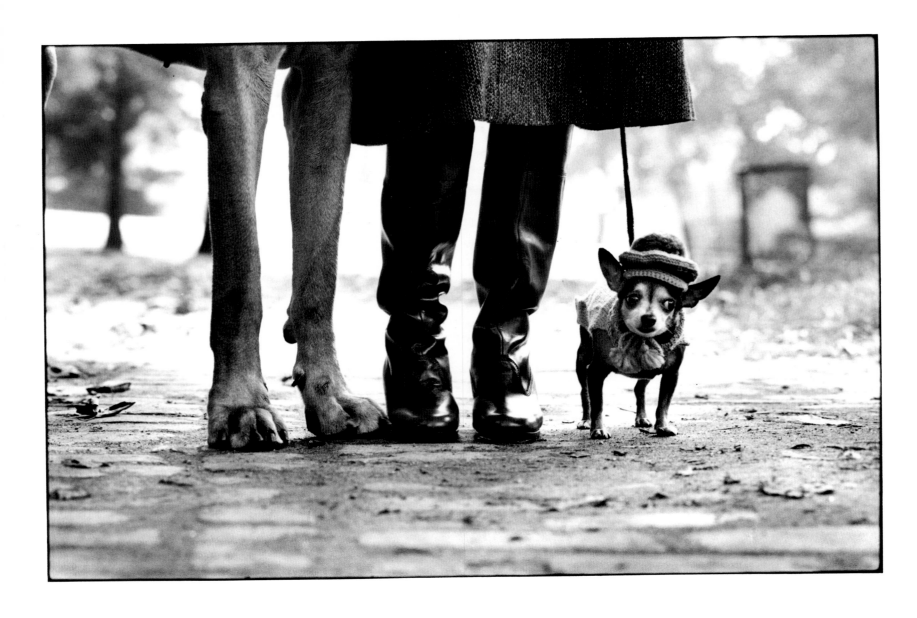

New York City, 1974

To The Dogs

THIS BOOK IS NOT ABOUT DOGS.

These are, in fact, not pictures of dogs at all.

Look again.

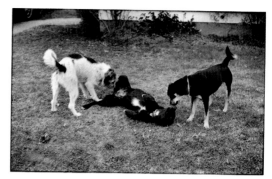

Santa Cruz, California, 1972

ESSENTIALLY, THESE ARE PICTURES OF PEOPLE. BUT IF I really took photos of people doing some of these things, I'd get into trouble. More trouble than Mapplethorpe. Besides, it's a lot easier to photograph these funny little creatures than people, as long as you don't get bitten. Dogs don't mind being photographed in compromising situations. So, these pictures are a "kinder, gentler" way of taking shots that would otherwise be considered unacceptable.

IT'S NOT REALLY THAT DOGS ARE NEVER SELF-CONSCIOUS. In fact, a cruel person, or a photographer, can easily embarrass them. But they are usually unaffected because of something like innocence, or lack of worldly experience. Perhaps that's why they seem to have such a natural bond with children. Maybe they still have some fundamental values that haven't been corrupted by society.

They're not exactly like children, though.

They're more nonchalant. They don't necessarily want you to notice that they're there, because they know that they belong. They don't keep having to say "Look at me!" the way your children do.

So maybe children are the closest thing to ordinary human beings, and dogs come in next.

DOGS HAVE MORE TO DO THAN CHILDREN. FOR ONE THING, they are forced to lead a life that is really schizoid. Every minute, they have to live on two planes at once, juggling the dog world against the human world.

And they're always on call.

Their owners want instant affection every day, any time of day. A dog can never say that he has other things to do. He can never have a headache, like a wife.

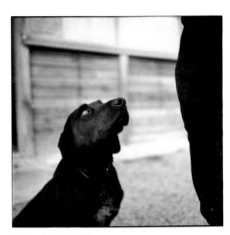

Milan, Italy, 1949

ACTUALLY, DOGS ARE ALWAYS TERRIBLY WILLING TO

please. They wait for the next order. They are ruined if they can't please the master.

Notice in these photos how often the dog is just naturally put in an inferior position because he has to look up at his owner.

Waiting.

A proud dog would choose a midget for an owner.

YET, WHEN THE OWNER HAS GONE AWAY, OR IS ASLEEP,

dogs are always going somewhere with an air of purpose and determination. Look how resolute they seem on pages 115–117.

Not one of them is simply strolling. They all seem to have an important appointment. (It usually turns out that they don't.)

Maybe they're just trying to get a whiff of the future. They certainly have a sense of the past. You can feel the memories of the wounded dog on page 39.

The automobile is the only natural predator of the dog.

ONE DOUBLE-PAGE SPREAD (PAGES 106–107) WAS INSPIRED

by a recent assignment in Milan for *Mirabella*. The magazine did a feature on Tiziana Fabbricini, a wonderful young opera singer known as the "new Callas" and shown on page 105. (She has a great sense of humor, and I hope she's not yet famous enough to be offended by the spread that follows.)

Full-throated, pushing from the diaphragm, jaws loose on their hinges—the dogs are clearly doing something straight from the heart. Is it fair that we use such words as howl, bay, croon, yelp? What do we know? They hear frequencies we never will.

Signorina Fabbricini notwithstanding, I don't think this is grand opera . . . more like lieder, meant for a smaller audience that will pay attention to the nuances. Schubert, maybe, but without an accompanist. Music, nonetheless, at some level of hearing or understanding.

Or maybe not.

Rubens, the painter, always heard something else. A picture may be silent, but the dogs in his scenes yap. In the Louvre, there is a whole room of Rubenses. It's bedlam. I think there is a loudmouthed little dog yapping in every one. Not one Callas.

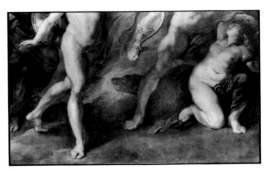

Paris, circa 1614

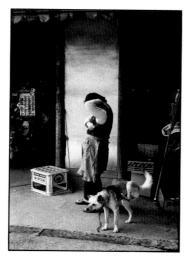

Kyoto, Japan, 1977

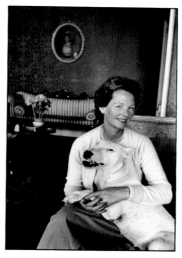

Brighton, England, 1956

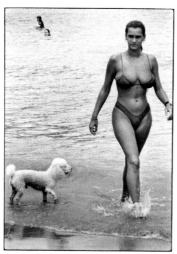

Buzios, Brazil, 1990

YAPPING IS USEFUL IF YOU'RE A DOG WHO HAS TO WORK for a living; say, herding horses.

The scrappy little fellow on page 38 has his career in Argentina. He has to be quick and agile, or he'll be knocked dead. He keeps at it until he gets scores of horses where he wants them to go.

Somewhere nearby, sitting on the veranda or in his car, the owner whistles commands, and the dog carries them out, and the horses go to the proper place, and I have a picture.

Everybody's happy.

SOME DOG-WORK LOOKS MUCH MORE PLEASANT, LIKE THE job of helping owners meet each other.

That's a big career for dogs in cities especially, where people purposely choose an animal that's unusual or peculiar. That way, it's more legitimate for a stranger to stop and talk about the dog. Striking up a conversation about an ordinary mutt is too obvious. Many enduring and wonderful friendships have been created because a pet is rare, or odd-looking, or unusually well manicured.

The type of dog you own also gives off social signals, like what you wear to a cocktail party. More than you think, your dog probably reveals your personality, and that can save a lot of time. And a pet can say something about your status, or your tastes. A woman restraining a Doberman in Central Park is probably very different from one who cuddles a Chihuahua in her arms.

But above all the dog should be friendly, because dogs often meet before their masters do. For a quick introduction, nothing's better than getting the leashes tangled. Then there's this new device, sort of like a fishing reel, that lets your dog wander off while you stay in one place. I suppose you could wait until your pet meets the person you want to meet, then reel them both in.

It's the only way most of us could possibly dare to meet someone like this Brazilian woman loping out of the surf. Your little dog can make your dreams come true, or at least get you an introduction. And the woman isn't going to sneer, and you won't be bopped on the head by the boyfriend. You're innocent. You were just making sure your pet was hanging out with the right kind of person.

DOGS ALSO WORK TO HELP BEGGARS WHOSE INFIRMITIES
aren't dramatic enough to get a response. A dog is a marvelous tool for eliciting sympathy, at least in the First World. People seem worried that it might not be getting fed properly or that it might not have a place to stay. They assume that if they take care of the beggar he will take care of the dog. That's the priority.

In the Third World, however, crippled children are used, instead. A beggar may rent an afflicted child if he doesn't have one of his own. Dogs need not apply.

OF COURSE, DOGS ARE VERY OFTEN A REPLACEMENT FOR
children, when yours have grown up and gone off, or if you've never had any.

Maybe better than a replacement. They give sure-fire affection. "The dog is a Yes-animal," says Robertson Davies, "very popular with people who can't afford to keep a Yes-man." In fact, it's an unusual dog that doesn't give back much more than you give, especially when it comes to loyalty.

But what happens to the dogs of divorce?

Who gets the dog? Are there visitation rights? Do dogs have to deal with "denial"?

ACTUALLY, I HAVE A CLUE. WHEN I WAS ABOUT THIRTEEN
or fourteen years old, living in Hollywood, I had a bald-eared, mutty dog, mostly German shepherd, named Teobaldo. "Terry," I'm ashamed to say, for short. Absolutely the wrong name for someone so brilliant and worldly-wise.

My parents were going through a divorce, and I lived with my mother, but when I was fifteen, my father skipped town, and I moved into his house and turned it into a kind of crash-pad, though that wasn't the word then. In fact, back in the 1940s, we didn't even know about beatniks, though I guess my high school friends and I lived for a while like very young beatniks without beards. And that's when I began teaching myself how to take photos, though I had no idea it would go on for the next forty-five years.

No, crash-pad is definitely not the right word. I prefer "salon."

Anyway, my mother was living in a nice little house up in the Hollywood Hills. My father's house was about four miles away, down near the action on Hollywood and Vine. To get from one to the other, you had to cross several busy thoroughfares, like Western, Hollywood, Sunset . . . "Terry" did just that, all on his lonesome. One day he just showed up.

From then on, he worked out his own pattern of "visitation rights." He would hang around for two to three weeks, then decide to go back to the hills for a while. When he was around, I'd go down to the Ranch Market and get him a special treat, like half a lamb's head, and he'd chew on it for days. But he didn't necessarily leave when he finished. He simply had an agenda of his own. He would just exchange the city for a nice suburban neighborhood, and vice versa, whenever he felt like it. Think how much that would cost a human being.

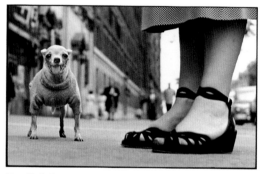

New York City, 1946

BUT THERE ARE NO PICTURES OF TEOBALDO HERE. IN FACT,

I've never set out consciously to take "dog pictures," either of friends or strangers. I just simply noticed one day that there seemed to be an unusual number of these curious creatures in my commercial work and in the snaps I take for myself (called "art" when they're on a wall or in a book like this), so I started putting them together.

Long before that, however, in 1946, my first "dog picture" was published—that little Chihuahua wearing a sweater. People like to point out that it's taken from the dog's point of view, but the dog, of course, isn't surprised by that, as you can see. He's completely ignoring the person next to him, and her point of view.

I've often wondered what happened to that dog. The picture has been copied many times, though it is not, to say the least, based on a very profound concept. I've done several more pictures like it myself. Maybe I'm lazy.

In a 1974 ad for boots, I did something similar with a hired Chihuahua and a hired Great Dane (see page 6). These professional dogs have several advantages. They come cheaper than hired humans. They're visually more attractive, in the sense that each has a distinct look. Girl models all look alike; they're all the same size, tall and skinny. They fit the year's fashion. With the dog models, I see the subtle individual differences. No fashion trends for them.

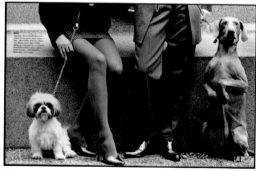

New York City, 1989

IT BOTHERS SOME PEOPLE THAT THE HUMAN MODELS HAVE

no faces in some of the ads I've done for shoes, but if I showed the entire person, you wouldn't focus on the footwear.

My dog models get us down to the right level for examining boots and pumps, and they give eye contact, too. Snakes could get us even closer, but they seem wrong, somehow. Cockroaches are the right size, too, but they aren't very sympathetic, unless they're intellectual, like "archy" the cockroach.

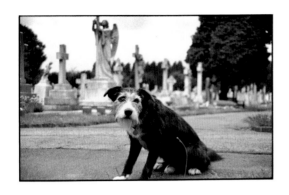

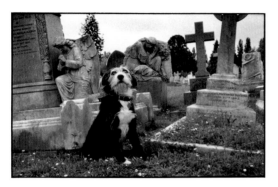

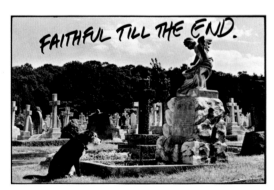

London, 1991

THERE'S ANOTHER ADVANTAGE, WHEN I'M DOING COMMER-
cial shoots, to staying down at dog's-eye level. Working below the girl model's knee
gets me free of those tyrants of the business, the hair and make-up experts. They
have power, and they can exercise it viciously. Just when everything is set, they can
always find some last-minute detail that has to be fixed. A long day of this is pure
torture.

Professional dogs make the day simpler. They don't need hair-dos and make-up. They
come prepared.

I'VE BEEN STUPID ENOUGH TO FORGET THAT. A WHILE
back, I had a dog that I would trim every summer, just at the beginning of the sea-
son. He would be so ashamed that he did not like to be seen in public for the first
few days, until the hair began to grow back.

And yet he would always submit, just as dogs tolerate the baths we inflict on them,
even though he would be mortified. Especially in front of other dogs. They didn't get
the fashion statement.

MOST OF THE DOGS IN THIS BOOK WOULD FEEL THE SAME
way. They're naive. Few of them are professional. There's a famous exception on
page 133, the dog who played Sandy in *Annie*, snapped in his dressing room. As
makes perfect sense, the star is the one on top; that's his understudy down below.
Professionals know their place.

Onstage, that dog squeezed your heart. He had a few lines, a few bits of stage busi-
ness. When he died, *The New York Times* ran an obituary. Somebody realized he was
a person.

THERE'S ANOTHER SKILLED PROFESSIONAL IN AN AD I DID
for Levi's jeans last year.

That woebegone expression of a scruffy dog pining for his dead master in a graveyard
is not exactly priceless; it cost a lot of money. So did the cemetery, the Putney Ceme-
tery just outside London. It's harder than you might think to find a graveyard with
stones standing upright like that.

Of course, the picture doesn't make sense. The newest headstone is about seventy years old, so this dog would have to be very faithful, indeed, if he was still mourning his master after all this time. And have a good memory.

The fourth picture in the series is the one used in the actual advertisement. The others give you a sense of what a thespian dog has to go through. I was trying him out in various settings and poses to see what worked, to get the best match of his expression and the location. We went through dozens and dozens of possibilities.

The final shot looks like the obvious one to use, but I didn't know that until I'd seen all the others. He didn't, either.

As a professional hangdog dog, this model was absolutely terrific. I'd recommend him anytime. He seemed to have two little people inside him, one that on command would take him trotting to the left, the other to the right.

In this kind of work, it's always good to have a model that doesn't wonder why you're doing what you're doing.

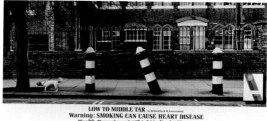

London, 1991

THE AD PHOTO FOR EMBASSY CIGARETTES, A BRITISH brand, is unique in this book.

It is the only electronically doctored picture! In life, all of the poles stand erect; the middle one was tipped sideways in the lab.

Some people thought it would be funnier to have the dog tied to the leaning pole. They lost.

What's really remarkable is that the ad agency was not afraid to run the picture. In England, you cannot have anything "positive" in an advertisement for cigarettes and other tobacco products. In this case, for example, the photo was in color, showing green grass. Too "positive." Electronically, the grass became brown. No suggestion of cheerfulness is allowed.

You can be funny, though, in the twisted British way. Hence, the leaning pole.

But what about that dog? What is more "positive" in the British Isles than a dog?

Perhaps he's a little "negative," after all, because he's evidently had to go into "trade" for a living rather than loll about his manor house.

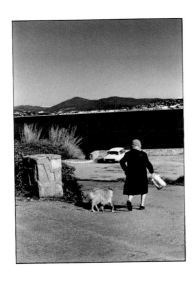

BUT MOST OF THE DOGS YOU SEE HERE ARE AMATEUR
dogs.

Still working at it.

Take this series of photos in quite a different graveyard, a more contemporary version
in Saint Tropez. The dog is cooperating with me without knowing it. This whole epi-
sode was the result of pure luck. The chances of four shots happening like this are
extremely remote, which is probably what makes photography so special for me. You
just follow your nose, and sometimes you get a kiss at the end.

Of course, the dog is also cooperating with his mistress, without knowing why. She
goes to the cemetery. He goes, too. Dogs will follow along just about anywhere you
want them to, no questions asked.

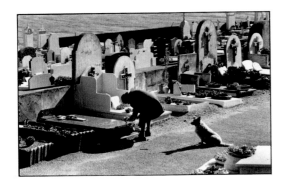

BUT THEY ARE NOT GOING TO POSE LIKE STATUES, BECAUSE
they just don't get what you're talking about. Their own vocabulary is so limited.

That's why, by the way, you could make a fortune if you find an old daguerreotype in
the attic with a dog shown clearly. Such photos are rare and valuable. It took so long
to take them that the dogs always found something better to do.

When you point out something to a dog, he looks at your finger.

—J. Bryan III

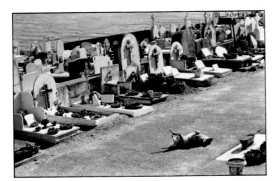

IT'S NOT FAIR, BUT PEOPLE HAVE THE POWER OF LIFE AND
death over dogs. You just take your dog to the pound, and that's that. It's legal. But
not the other way around.

THERE'S A TERRIBLE DRAMA IN LATIN COUNTRIES, AT THE
end of summer vacation. All through the holidays, a kid plays with a new dog, often
just a puppy, and then the dog is abandoned at the very beach where it got so much
attention.

Saint Tropez, 1979

I must have seen this a lot when I was a child growing up in Italy, because my family faithfully took the obligatory bourgeois month at the beach every summer. I certainly never abandoned a dog like that myself. And I have no idea what happened to all the dogs that were left behind. Was it impolite to ask? I don't remember.

Anglo-Saxons throw up their hands in horror, but let them try to find a home for a used dog! It's almost impossible.

OF COURSE, IT'S USUALLY A CASE OF THE USED MASTER, since dogs live such short lives. Take the Irish wolfhound on the cover. The breed is so dumb and lovable you really get attached, but they have a terrible drawback. Even for dogs, they don't live long, no more than seven or eight years. You love them. They die.

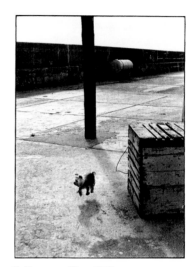

Ballycotton, Eire, 1968

This particular one is obviously intent on one task, just trying to please. He has no idea that his concentration on the business of properly fetching a stick is perhaps out of proportion in the great scheme of things. It's what he's supposed to do.

THE YORKSHIRE TERRIER ALOFT WAS NOT QUITE SO SELF-effacing. He didn't jump straight up in the air like that to please me, but because I barked.

He never got used to it. Every time I barked, he jumped.

I often bark at dogs. Not just because it's fair, since they bark at people, but because I might provoke a reaction that works on film. Dogs don't generally change their expressions, but a rude noise can get you a glare or a shocked look. To capture a unique picture, you have to challenge their sense of security, make them a little bit uncomfortable, or they will pay you no mind. Besides, it's always good, they tell us, for the photographer to strike up a relationship with his subject. Anyway, the dogs can't talk back.

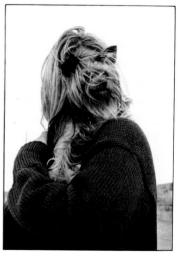

Ballycotton, Eire, 1968

My second wife and I bought this particular Yorky in Ireland for her mother. The same dog is tangled in my wife's hair. After I had my way with it in these photos, it wound up living in Queens and had the full and happy life of a New Yorker.

The breed has a bad rep because society ladies keep them as lap dogs and go silly over them, and you have to admit they are a little too cute. Maybe that's why it's so much fun to bark at them. But the truth is, they're hard-working dogs in their own environment, especially good at getting rid of rats.

Dog-lovers know that each dog is an individual, but it is also true that each breed has unshakable characteristics. You can't really pamper the terrier out of a Yorky.

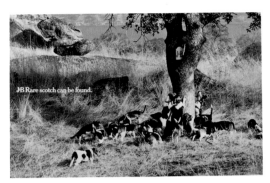

Sonoma, California, 1975

AND YOU CAN'T TRAIN A HUNTING DOG TO TREE A BOTTLE of Scotch, at least not in time for an ad shoot. Dogs aren't known as alcoholics; they're not even interested in booze.

The secret of this picture lies in the steaks nailed to the back of the tree. We had to feed the hounds a bit of meat, then lead them up to the tree trunk and practically draw them a map to the dangling steaks. This is not a pack of hounds that just burst eagerly out of the woods because they sniffed fresh meat from afar.

But they did well enough, and they got paid in meat while their owners got a lot of cash. This was in northern California some years ago, so I guess the money went into real estate.

Dachshunds are ideal dogs for small children, as they are already stretched and pulled to such a length that the child cannot do much harm one way or another.
—Robert Benchley

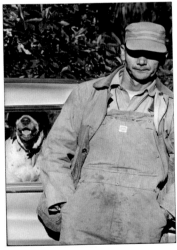

South Carolina, 1962

BY THE WAY, NOT ALL OF MY WIVES (WELL, THERE HAVE only been three, and six children) have felt happy around dogs. That's one reason I've rarely had a dog since my teens, along with being unable to bear seeing them die. Eventually, you always have to put them down; you never see them through their old age. You can't bring them to term.

And a free-lance photographer lives too much of the time out of a suitcase. I'd have to leave a dog in a New York City apartment all by himself for days at a time, at the mercy of one of those professional dog-walkers who would stop by twice a day and leash him to a pick-up team of other dogs.

I've never been interested in team sports. Any dog of mine wouldn't be, either.

Or maybe he wouldn't be like me at all. We might have the wrong idea about dogs coming to resemble their owners in temperament and looks. It could be the other way around. Hard to tell, no matter how closely you look at some of the dog-and-owner photos in this book.

THERE'S A LIMIT, OF COURSE. YOU CAN PUT A CHINESE AND a Sicilian dog on facing pages (pages 128–129), and they fit. They could be from the same country.

Putting their owners next to each other would tell a very different story.

So you can probably count on certain characteristics of dogs throughout the world. They don't learn to look Italian or Chinese. They are internationalists.

Except maybe for South American dogs. They aren't like dogs anywhere else. They always look as if they've just been peeled.

Dogs are also timeless, in a way humans aren't. Look at the photo of the dog at the ruin, in Sicily (page 129). He could be a dog from centuries ago (except for the fact that there were no cameras then). But any human being would immediately date the picture, almost to the year and certainly to the decade.

Even naked, like the dog.

BUT HUMAN ATTITUDES TOWARD DOGS, THAT'S WHERE each country is so different.

The four photos on pages 80–81 are unmistakably 1960s middle America. Since they were made to sell insurance, I guess they tell you what's important in life. For this commercial project, I always insisted that the family dog be included. That made sense to the dogs, of course. They felt as much a part of the family as anyone else.

You can see people taking responsibility for the dog's well-being, just as they would with a baby. Is it posed properly? Is it having a good time? Is it smiling? In one photo, two boys are wearing the same shirt as the dog.

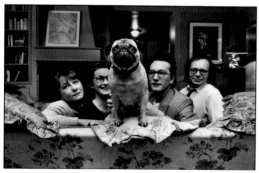
Paris, 1989

The American family dog is a very informal animal. If it knew how to wash dishes, it would pitch right in after dinner.

DOGS ARE MUCH MORE FORMAL IN EUROPE.

In France, for example, the dogs are more intellectual than in America. They know they're part of the social fabric. You can see it in their expressions.

They are also very territorial, in a specifically bourgeois way. They are confident that it is their butcher shop, or cafe, or country estate, and ever will be.

I've never found French dogs to be overly generous, and they certainly have no sense of humor.

THE FRENCH DOG-OWNER SHARES HIS PET'S HIGH OPINION
of itself.

Dogs are often taken to the business office in Paris, where they behave very well, discreetly listening to important conversations. Dogs are allowed in restaurants and in shops, since it is assumed that they will know how to conduct themselves. They certainly do.

That is a Parisian dog eyeing us from the front seat in the photo at the bottom of page 120. French dogs are less friendly to strangers than American dogs. They have to be properly introduced.

The poodle on page 54 is dealing in a characteristically Gallic manner with a problem that most of the world's dogs face: how to maintain dignity when tied up, as happens much of the time. The trick is to keep a sense of decorum within oneself, I suppose. At least, that's what I think the French dog knows how to do.

CURIOUSLY, THE FRENCH IGNORE SOME OF THE BASIC FACTS
of dog life. Because they've forgotten dogs are dogs?

Whatever, Paris is a minefield of dog excrement. Japanese-made poopmobiles come around from time to time, working a vacuum hose, but you have to remain vigilant.

I find this strange.

The English Dog Cult now vies with Christianity in the top ten religions.
—Spike Milligan

IT IS THE ENGLISH DOG, OF COURSE, THAT SEEMS TO HAVE
the most privileged position, but I think they have to work hard for it. They are not treated as severely as British children, of course, but they are highly trained and expected to perform. "Isn't he cute?" the American says when her pooch leaps up on you with muddy paws. "Down, sir!" says the Brit, and down it goes.

Saint Tropez, 1979

Paris, 1956

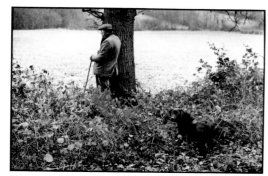
England, 1978

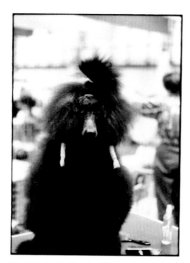
Birmingham, England, 1991

New York City, 1980

Still, the English never kick their dogs, the way Spaniards do. In fact, you will often see a kind of relationship between English owners and their pets that is so close it is simply unbelievable. I once had a British assistant who could make his black Labrador do practically anything, even walk backwards, probably because he knew dog psychology. I can't explain it any other way.

At its extreme, this kind of obedience is found in the peculiar, and often humorous, ritual of the dog show. This obsession is not restricted to the English, of course, but they wallow in it. Last year, I covered the Crufts show outside Birmingham. There were something like 25,000 dogs, all from the British Isles. Rumors flew about unlawful use of hair dye, lacquer and plastic surgery. The talk went something like this: "The ideal basset should have a fond, calm expression."

Through it all, the dogs play along. They want their owners to get the ribbons, and they'll stand in place without moving, if that's required, until their bladders burst.

ON PAGES 66–67, THERE ARE THREE STUFFED DOGS. IT'S not just the lighting.

One belonged to Napoleon. For the French, this seems to be sufficient explanation for stuffing the dog and keeping him on display.

Another is a stuffed notable British dog. He was a champion, but he bit people and had to be "put down." I suppose his owner could not bear to part with him and called the taxidermist. There he is in a Birmingham museum, part of an exhibition mounted in connection with the Crufts show, stuffed and put behind glass like Lenin.

But there is an etiquette to these matters. A placard on this stuffed dog explained the circumstances of his demise. When Prince Michael of Kent, famous for his love of animals, came to open the exhibition, the sign was reversed so he wouldn't be offended.

A stuffed dog is okay only if it died a natural death, I guess.

EVEN FOR ENGLAND, THE SCENE ON PAGES 24–25 IS eccentric. The dogs lying down with each other, something you wouldn't expect from a mixed pack like that, have all been collected by a homeless woman in a village near London.

She and her dozen or so dogs are famous. She feeds them well. They go along with her program.

But she became enraged and drove me away as soon as I took a couple of snaps. Maybe she didn't want anyone to see the dogs being so undoglike, amiably crushed together in such a small space without tearing at each other's throats. She might have been embarrassed for them. Or maybe she thought I was stealing their souls.

I would have liked to stick around and find out more.

Does she name them?

Does she talk to them?

When the British talk about Gladys or Campbell, Rosie or Mr. Mudge, you have to listen closely to find out whether they mean wife, husband, sister, neighbor or one of the dogs. You can't tell just from the way they use the names.

YOU HAVE TO BE VERY CAREFUL WITH NAMES, THOUGH.
They can have an effect.

The Alsatian owned by a couple I know watched cheerfully as they were mugged in the street one night, then loped down the street after the muggers, hoping to play.

I think that's what can happen when you name a dog "Alice."

THE AFGHAN PLAYING WITH MY YOUNGEST DAUGHTER
does not come from a very clever breed, but he's the kind of dog who really finds people interesting.

For some reason, he has taken a fancy to me, and I hardly know him! He always runs up and hangs on my every word; I mean, he really likes me.

Maybe I remind him of somebody, like his first owner. Dogs never forget their first owner. And that works the other way around, too. I know that many dog-lovers, no matter how many animals they have in a lifetime, always remember their first dog. And there will always be one particular dog, maybe not the first, that is remembered as very special. No other dog matches up. It's sort of like a great love affair you remember no matter how many times you get married.

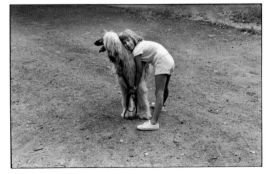

New York City, 1990

ANOTHER DOG WHO WAS VERY AFFECTIONATE TO ME WAS
Cecilia, the 160-pound Newfoundland being raped on page 100. She was clumsy and skittish about certain things, like slippery floors; she was terrified of the hardwood floors in my New York City apartment. And she refused to walk over subway grates.

Josh Billings wouldn't have approved. "Newfoundland dogs are good to save children from drowning," he said, "but you must have a pond of water handy and a child, or else there will be no profit in boarding a Newfoundland."

Cecilia, to my knowledge, never saved anyone from drowning. We all loved her anyway.

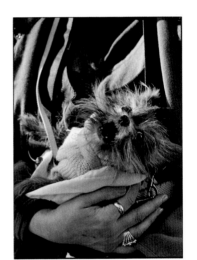

New York City, 1991

I'M STILL TAKING THEM.

Just the other day, there was a very informal, sweetly eccentric little dog show in Central Park, not far from my apartment. So that led to my most recent "dog shot" (left). I hadn't planned to go shooting dogs. It just happened.

There was an amazing variety of dogs and their owners, reminding me of the best things about New York . . . which are easy to forget when the bad things happen.

For all of our problems in the city, we have a wonderful spectrum of humanity. It's funny and charming and exhilarating, like a Fellini movie. But remember what Fellini said when someone asked him where he found all of his unusual-looking, grotesque characters?

"Look in the mirror."

IF DOG-LOVERS THINK THIS IS A DOG BOOK, THAT'S ALL
right with me. Especially if they buy extra copies for their dog-loving friends.

One of these little guys in here might remind you of a dog you know, or used to know. That's fine, too.

For me, the dogs are both an *excuse* and a *reason* for taking these pictures.

They give me an *excuse*, because they make good subjects. I like them; people want to see them; I can't resist.

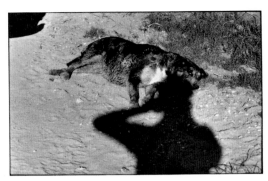

Stinson Beach, California, 1973

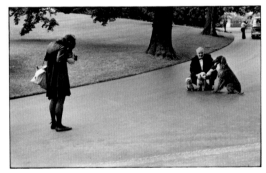

Washington, D.C., 1971

Some of the pictures have become so popular, in fact, that I've had to include them here—no more than six in all, I think—even though they've been in one of my earlier books. They've become part of my signature. I have mixed feelings about that. It's like being a singer who's always asked to sing an old hit song again; I probably wouldn't even remember these photos if they hadn't been reproduced so much. On the other hand, though, they do give me, and other people, a perspective on my work as the process continues over the years. So they're benchmarks, as well as golden oldies. They're here once again, special requests from someone in the back.

BUT THE *REASON* FOR ANY ONE OF THESE PICTURES IS THE same reason for taking a picture of anything. These are pictures of pictures—not about dogs but about feeling, mood, graphics. No matter what excuse (or subject) you use for taking a picture, it fails if it does not let something beyond come out, like your general attitude toward life, or your feelings toward the world around you.

BUT I DON'T WANT TO USE THE WORD "MESSAGE."

In all of these pictures, I hope, there's a kind of tug-of-war, a tension, between the story or description and the way it's been captured. Maybe some of these pictures are less well constructed than others, and so the "point of the story" is stronger than the purely pictorial. And maybe in some others the dogs are more important as elements in the composition than as actors in some event.

In general, though, it would be wrong to publish pictures that aren't pictures first, story second.

Every one of my photos of dogs is meant to be a photo.

Perhaps that remark sounds gnomic or cryptic, but I hope the photos you are about to see will show you what I mean. This is not a book of dog pictures but of dogs in pictures.

I loathe people who keep dogs. They are cowards who haven't got the guts to bite people themselves.

—August Strindberg

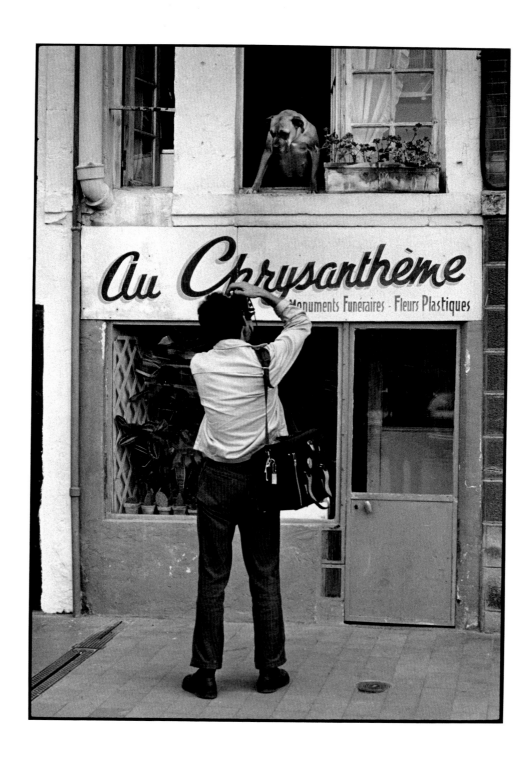

Honfleur, France, 1968

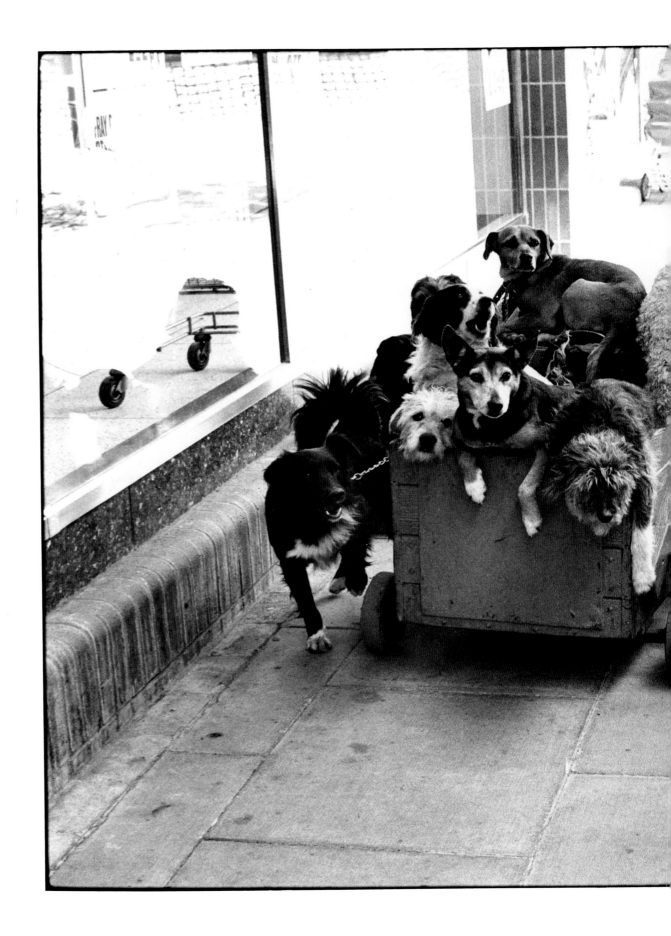

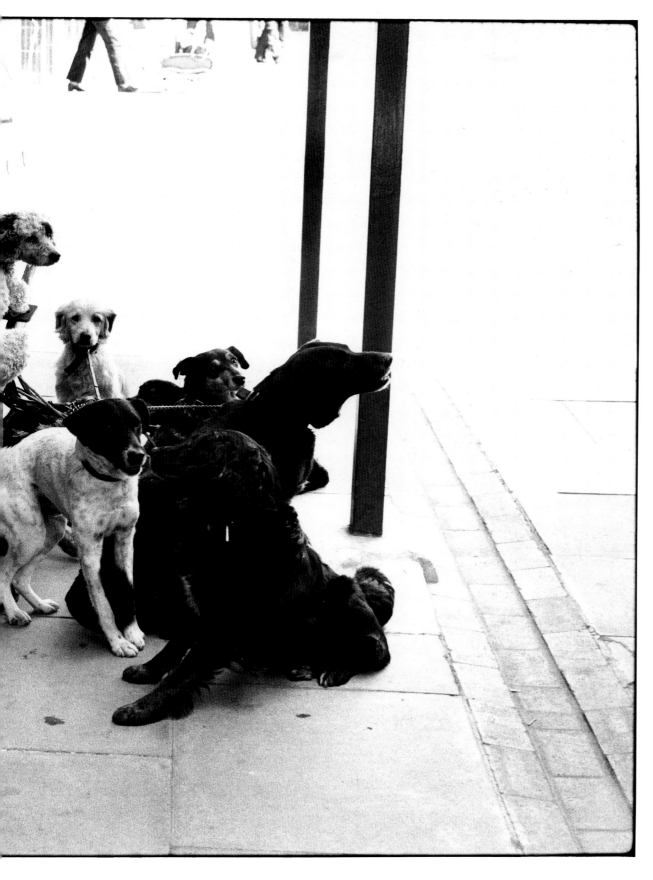

England, 1974

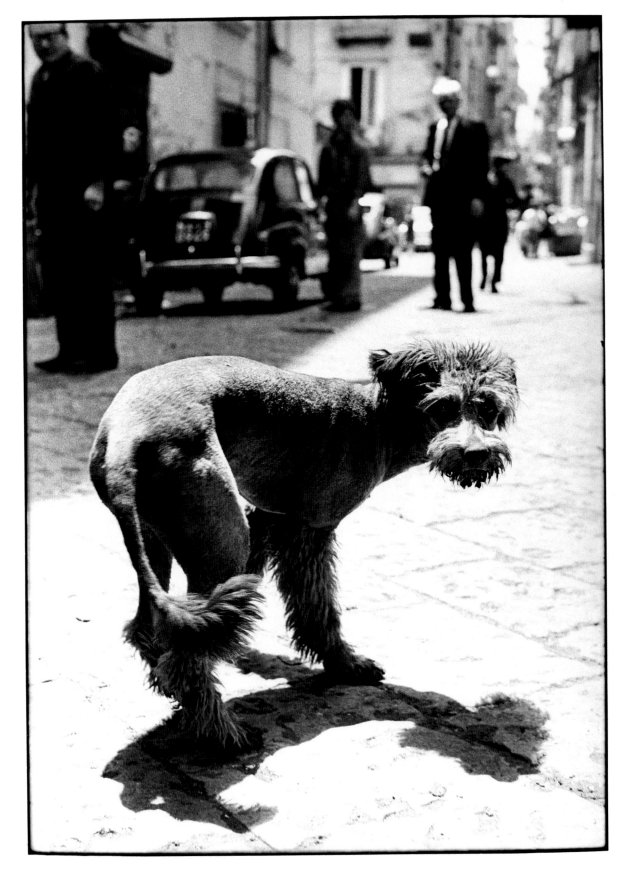

Rome, 1964

London, 1966

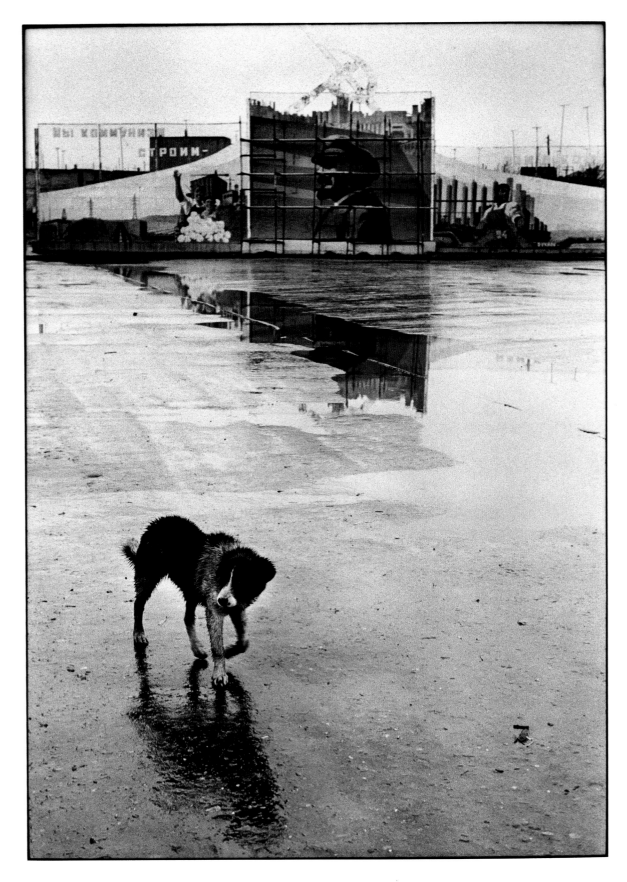

Siberia, 1967

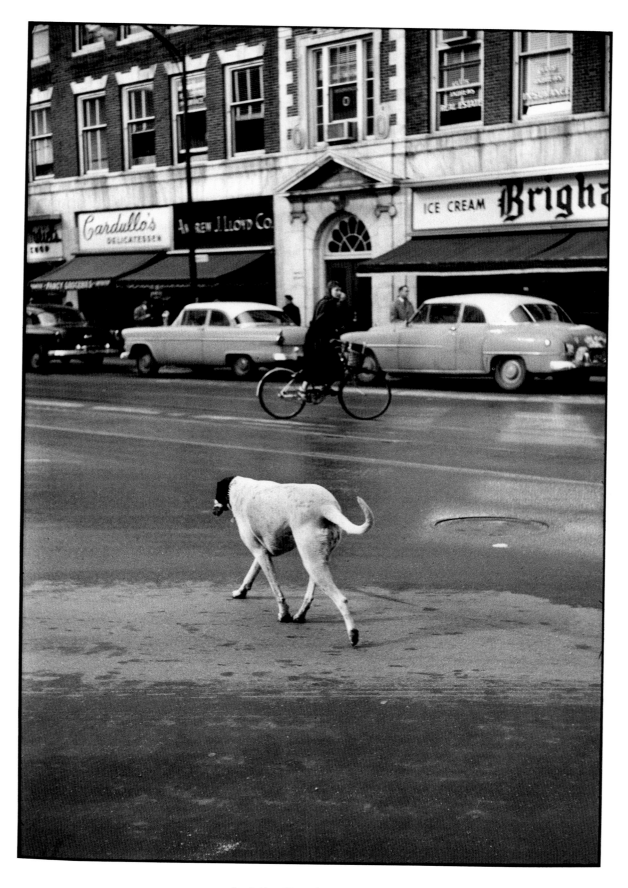

Cambridge, Massachusetts, 1958

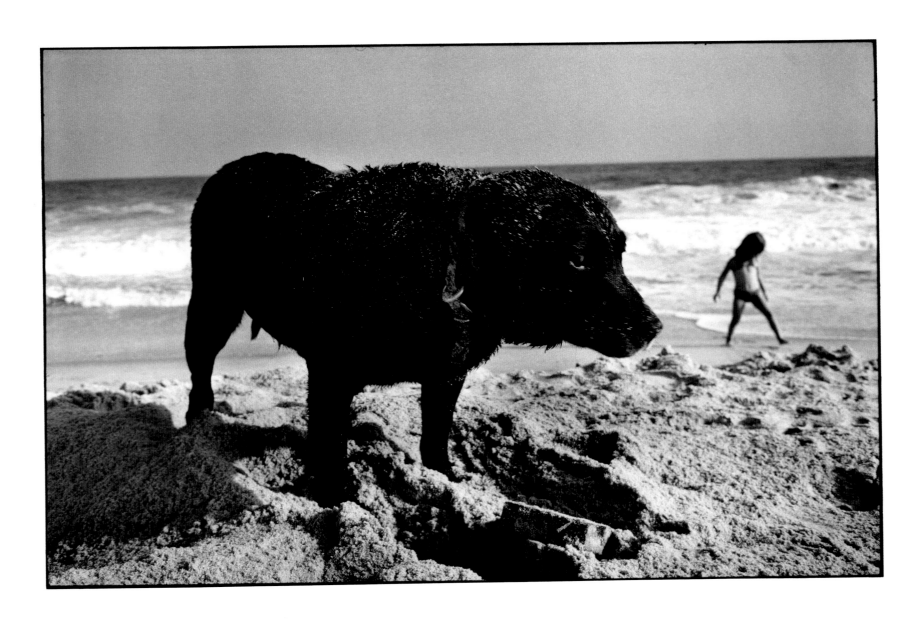

East Hampton, New York, 1981

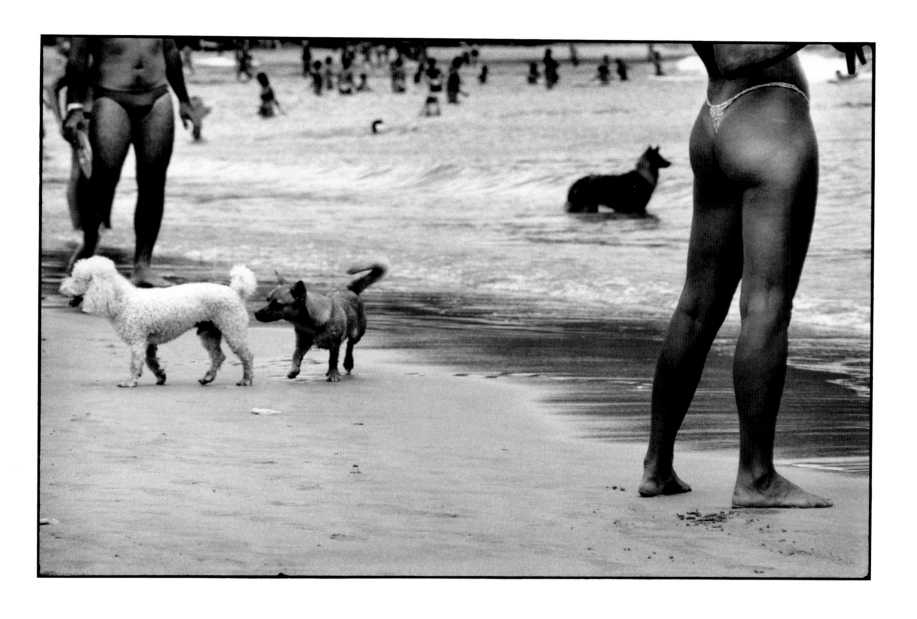

Buzios, Brazil, 1990

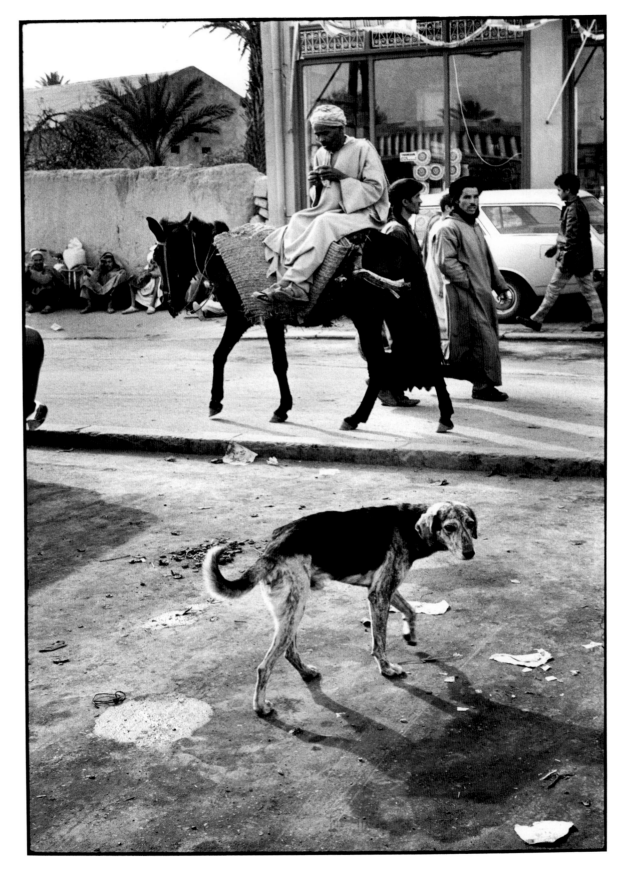

Agadir, Morocco, 1973

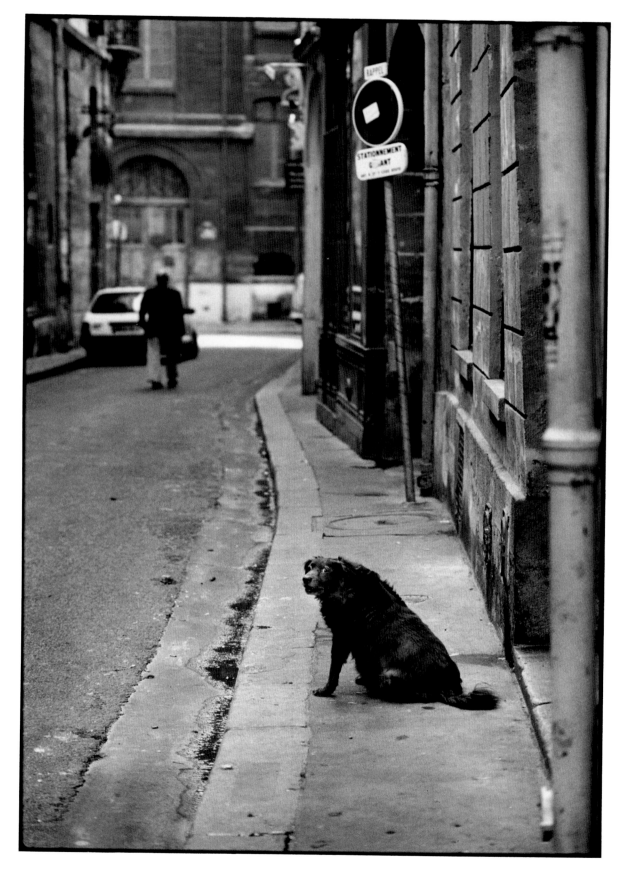

Paris, 1989

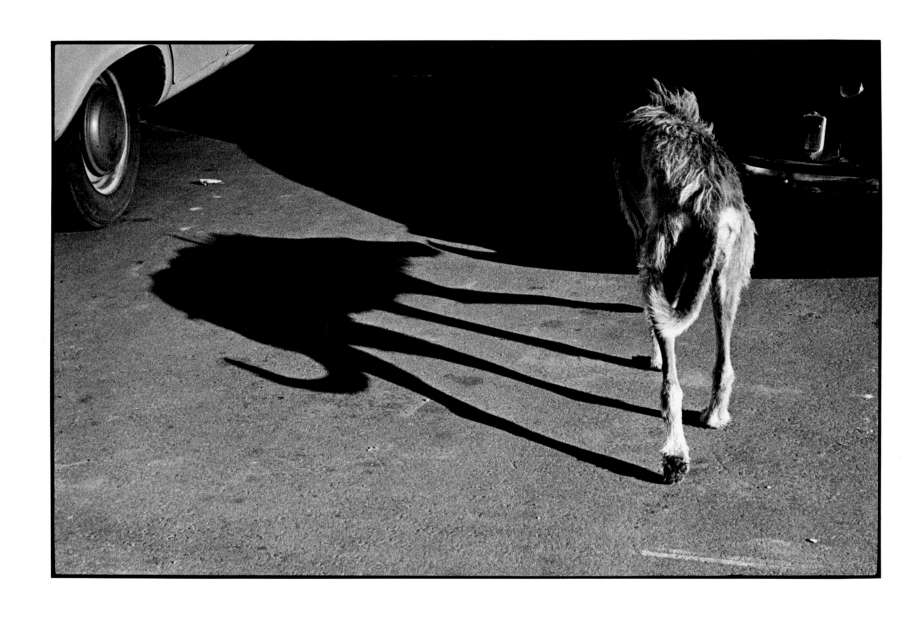

Melbourne, Australia, 1961

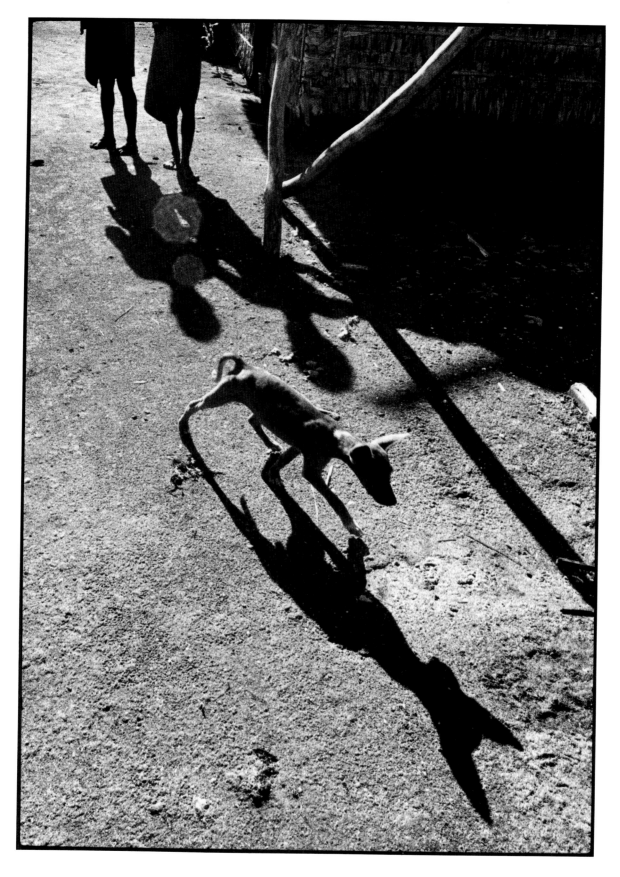

New Guinea, 1961

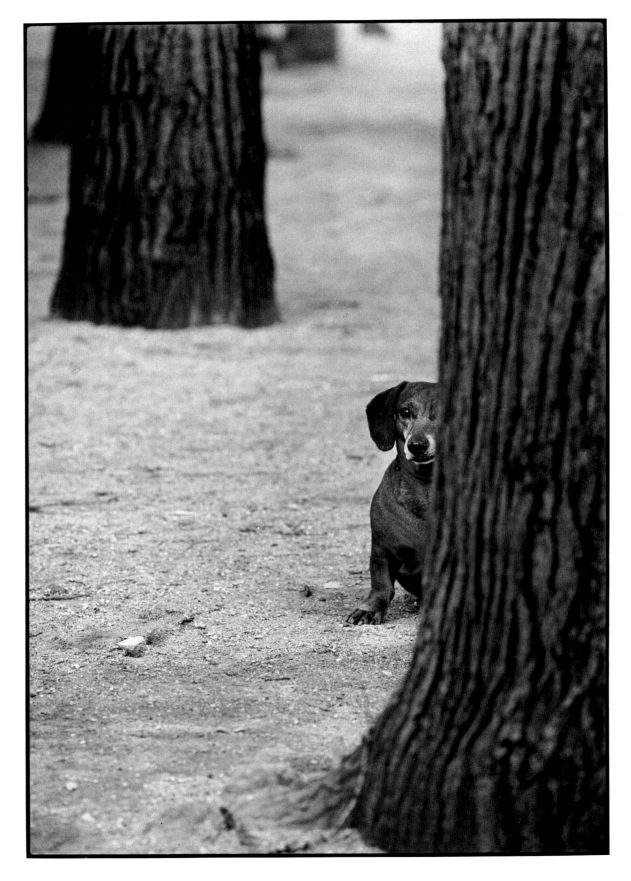

Paris, 1970

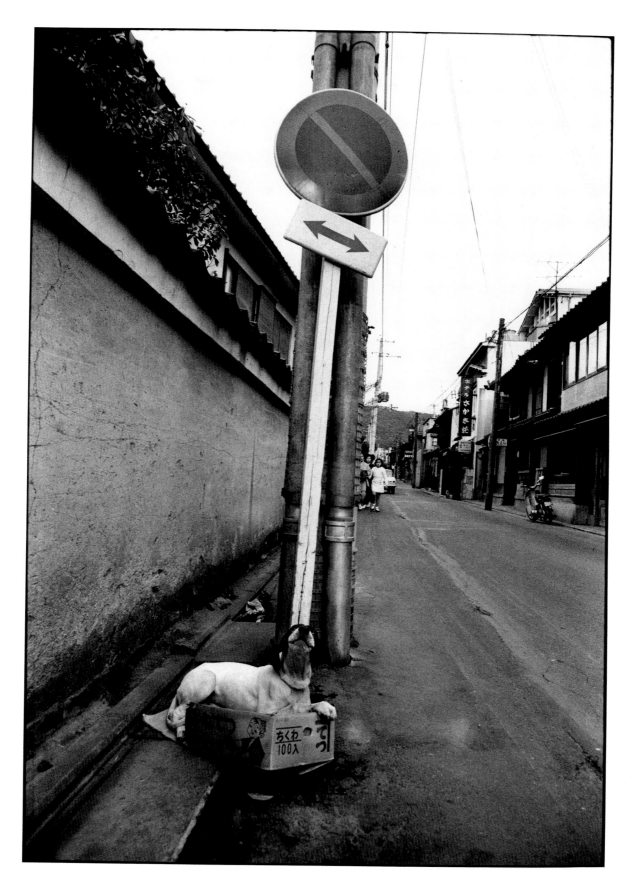

Kyoto, Japan, 1970

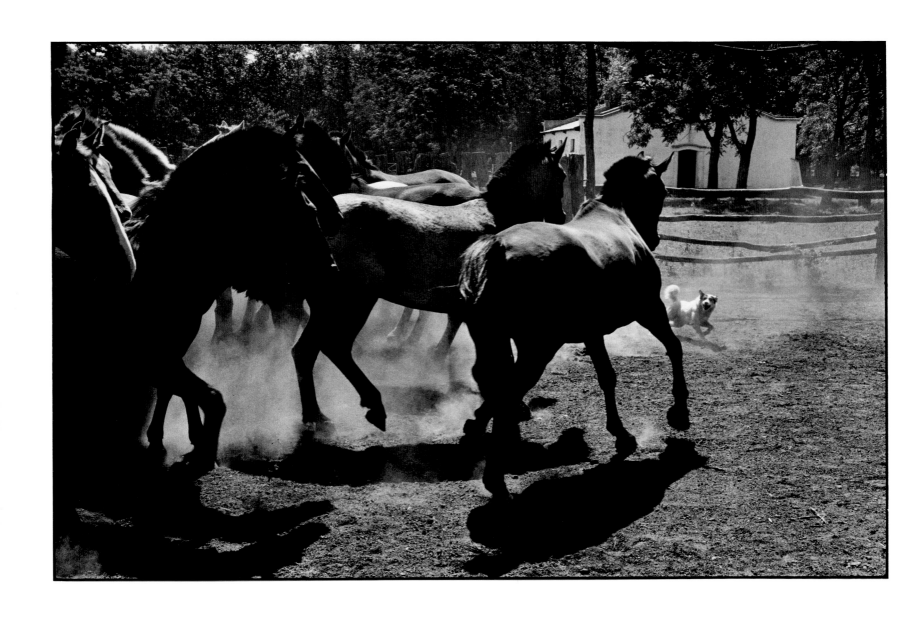

Argentina, 1972

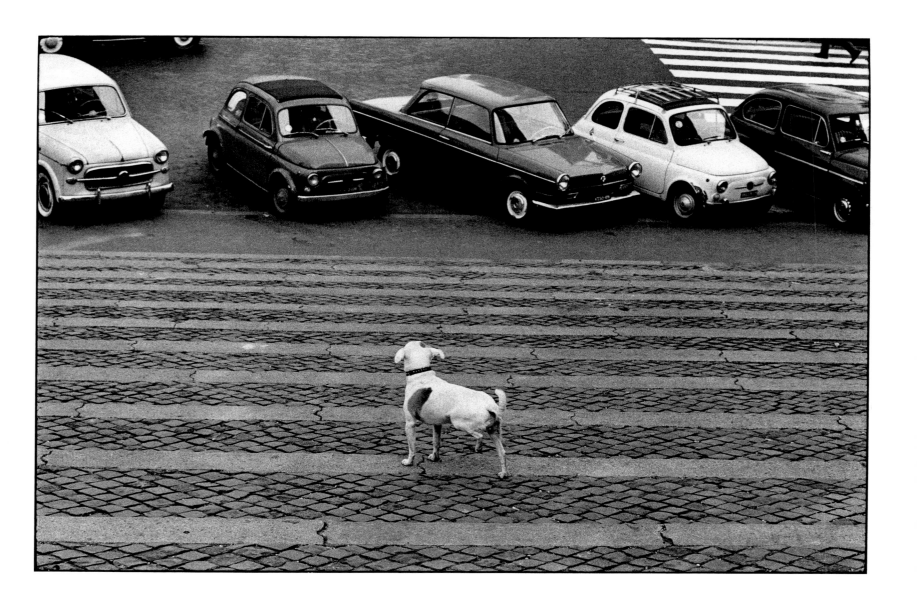

Rome, 1968

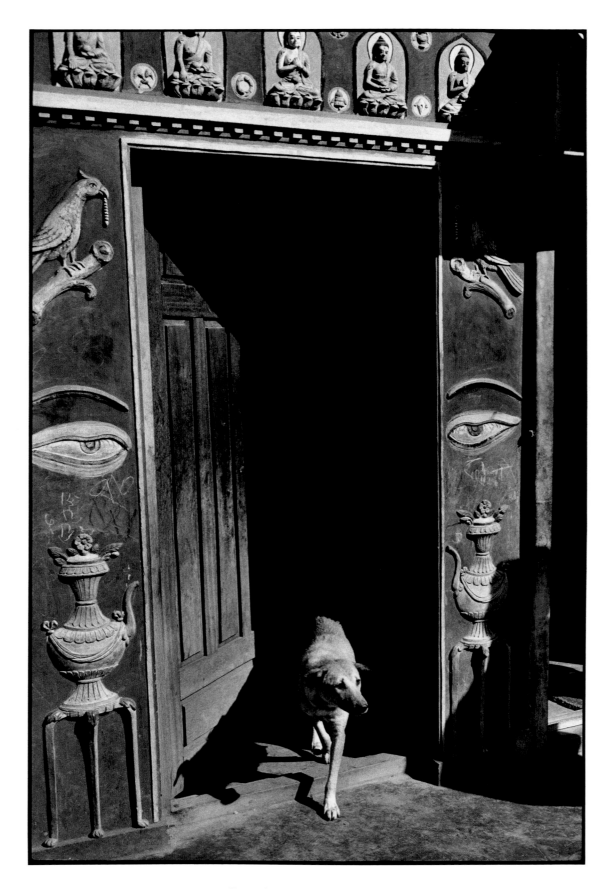

Katmandu, Nepal, 1983

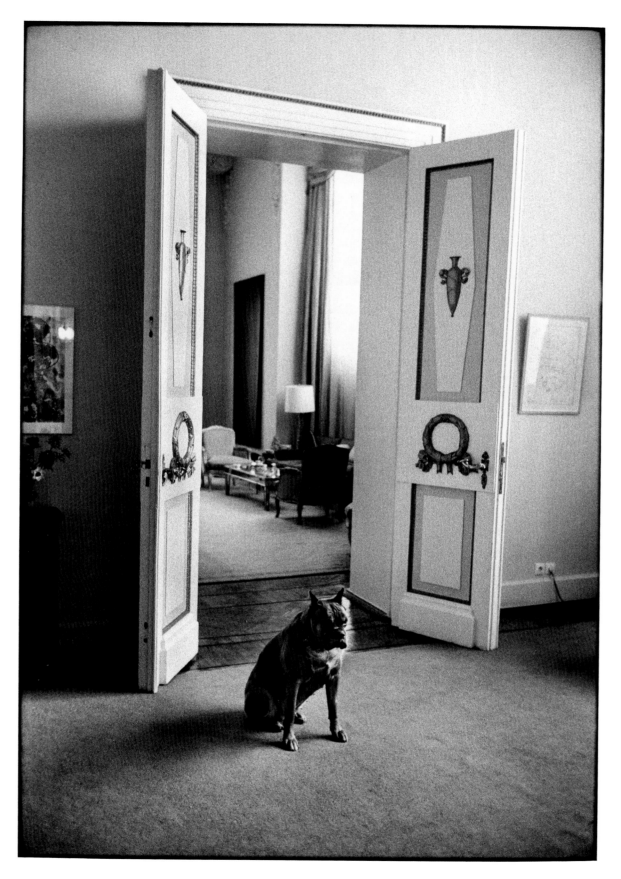

Moscow, 1968

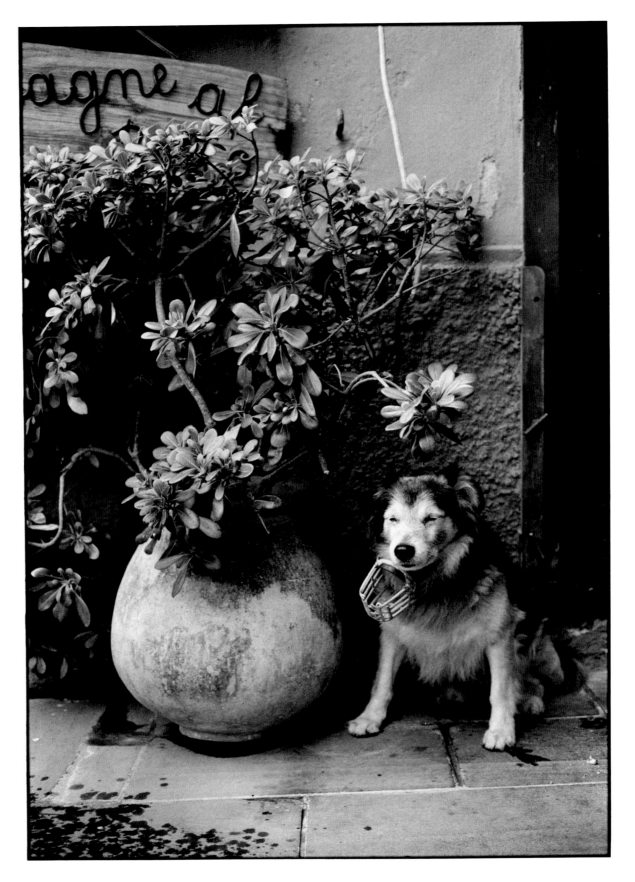

Positano, Italy, 1982

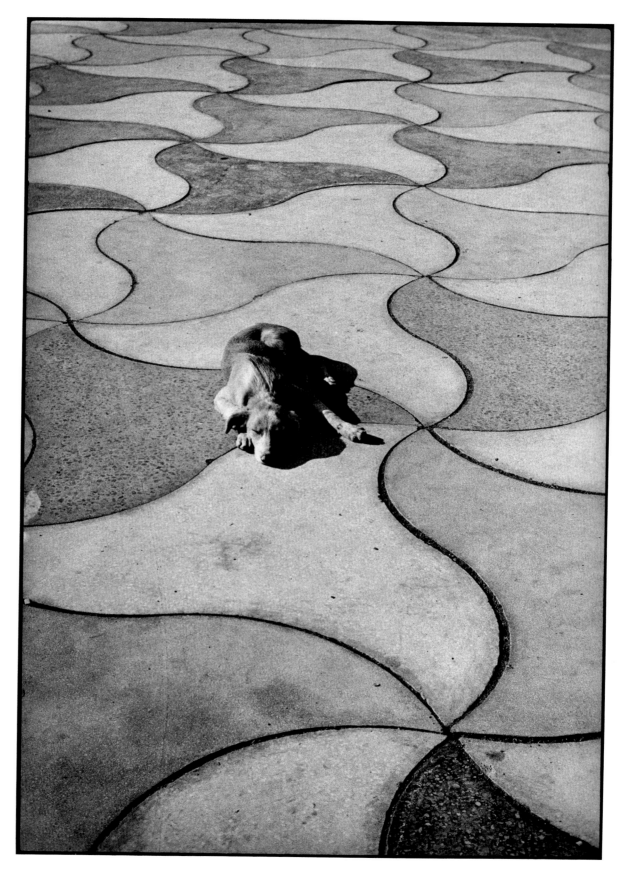

Spain, 1964

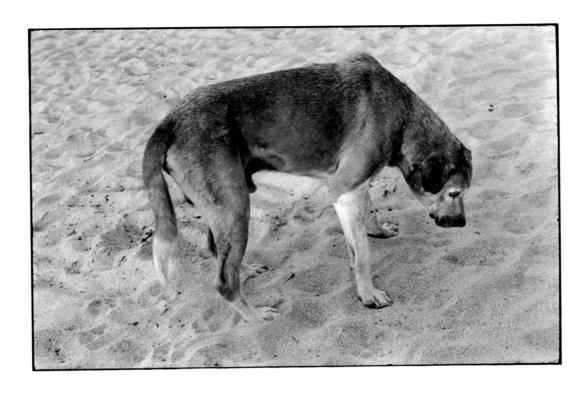

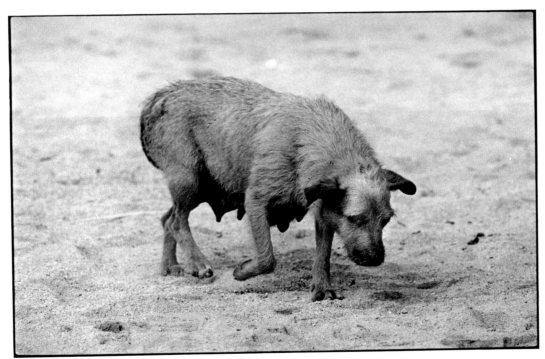

Puerto Vallarta, Mexico, 1973

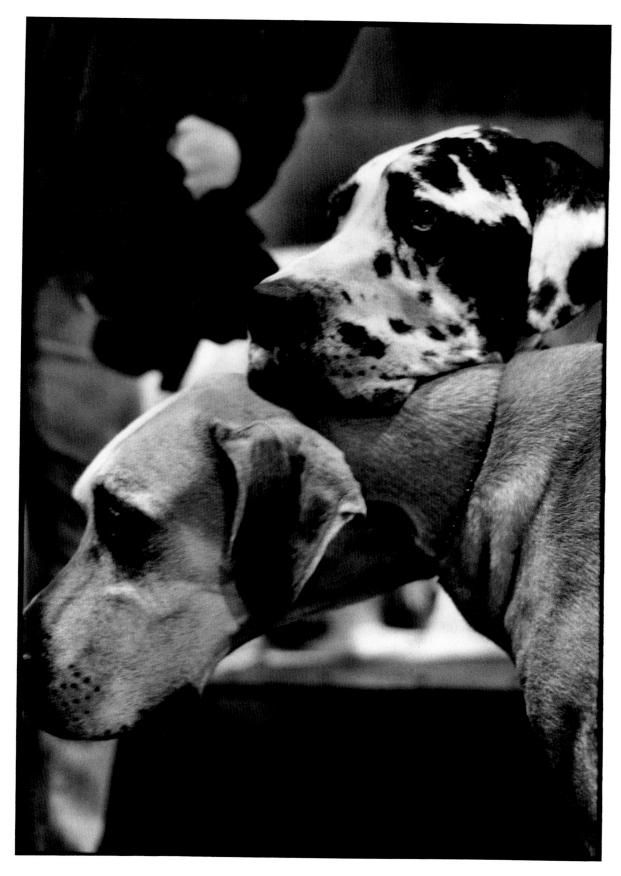

Birmingham, England, 1991

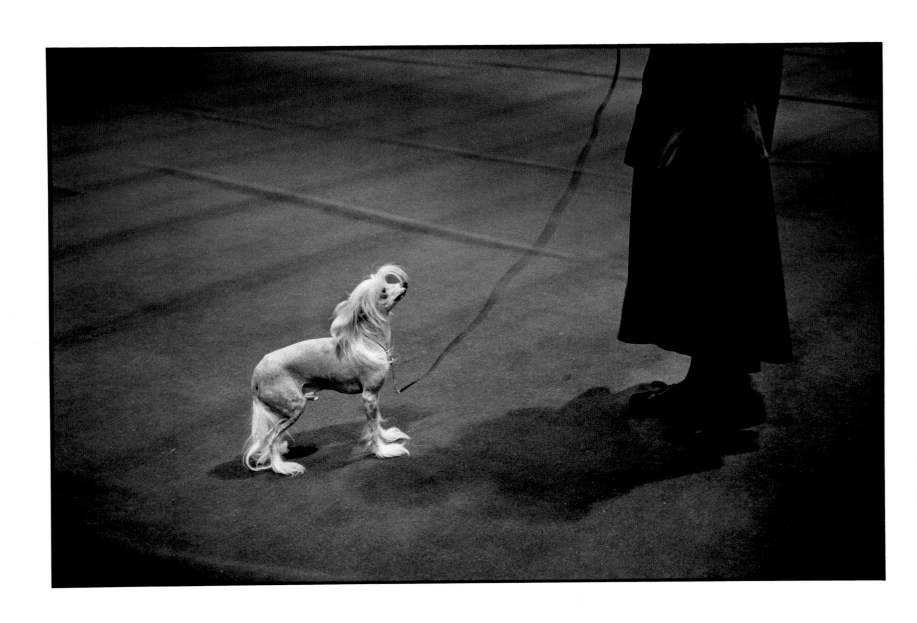

Birmingham, England, 1991

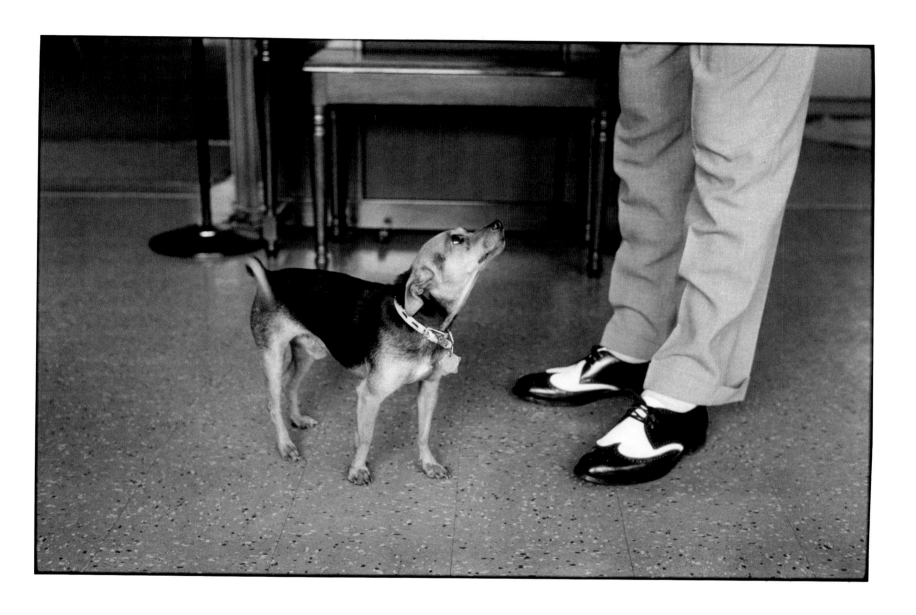

U.S.A., 1963

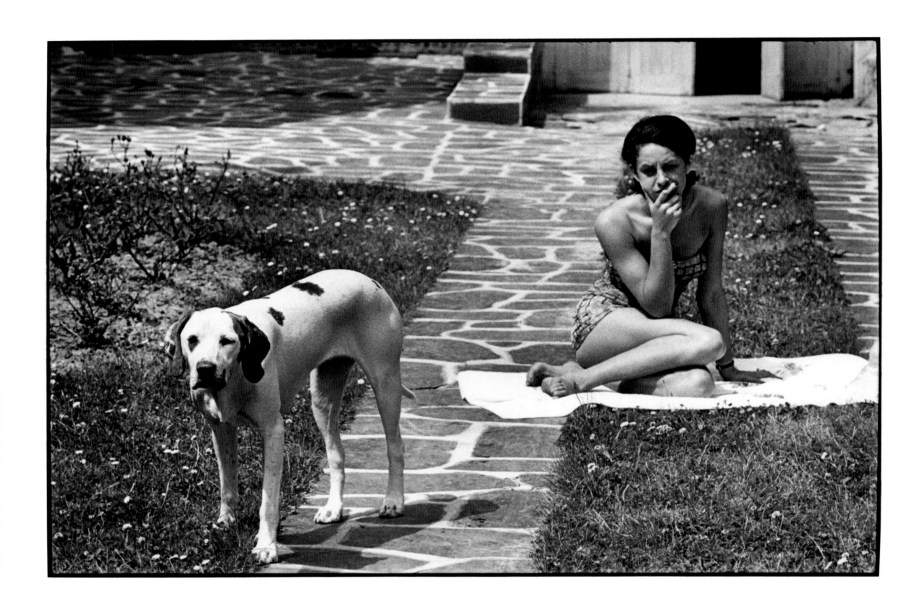

Trouville, France, 1965

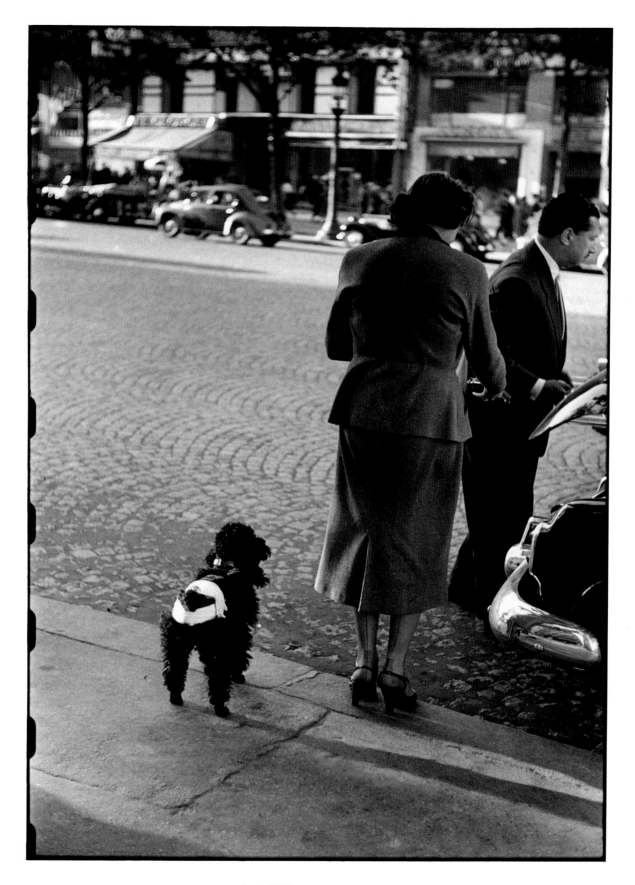

Paris, 1952

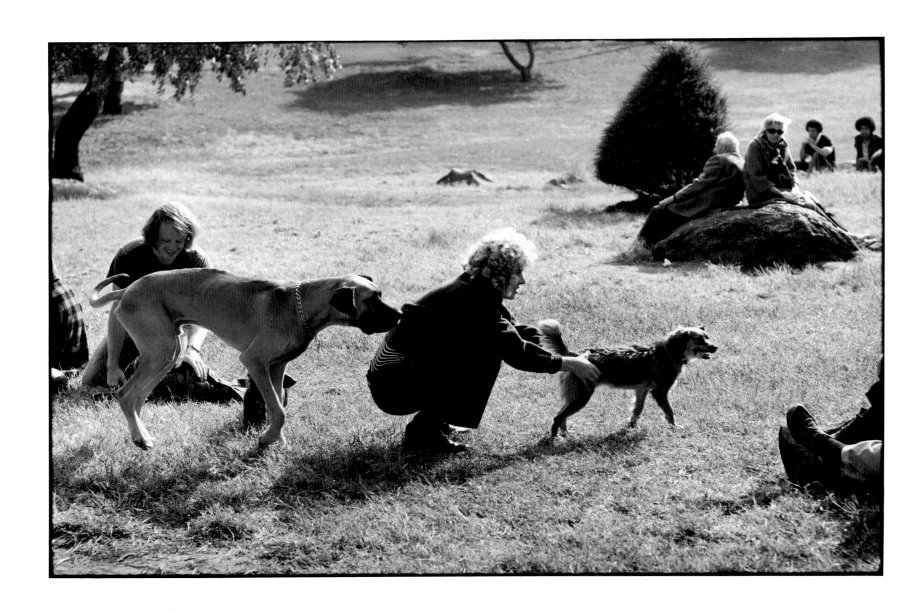

New York City, 1972

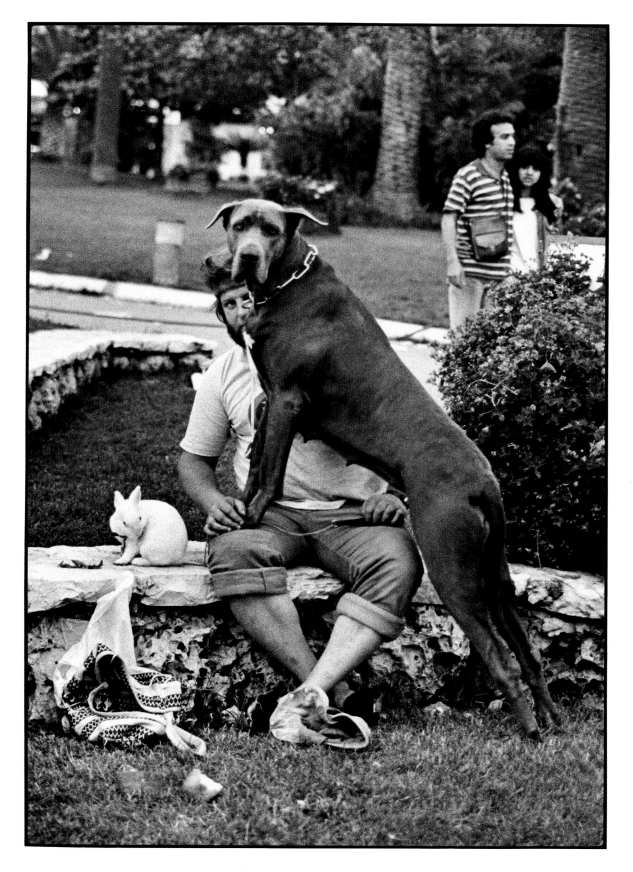

Cannes, 1980

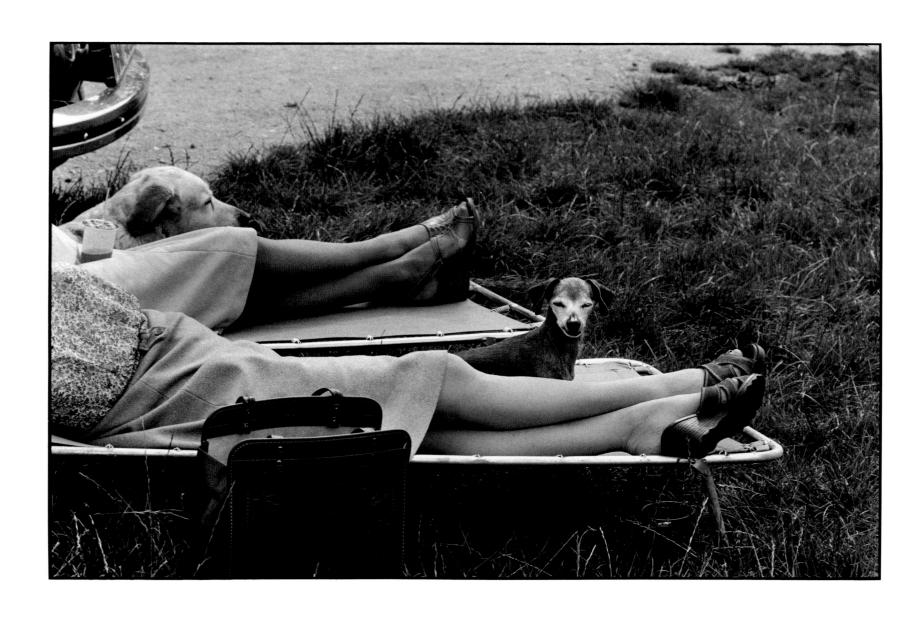

England, 1978

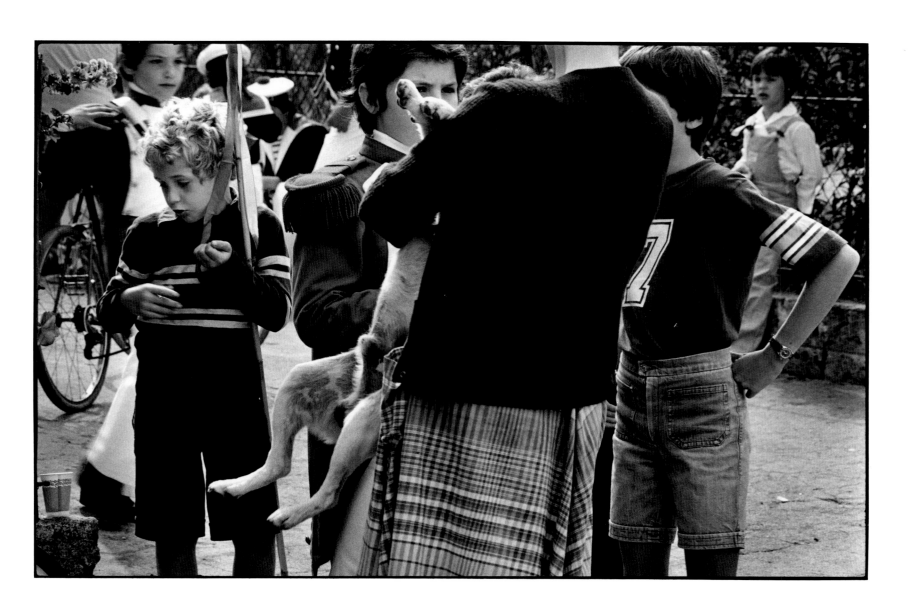

Saint Tropez, 1979

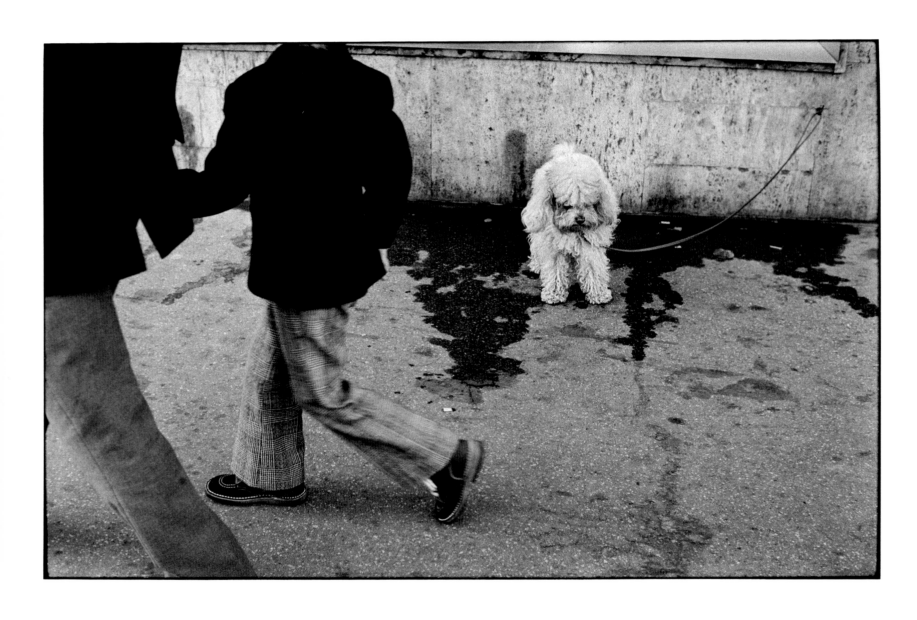

Cologne, Germany, 1972

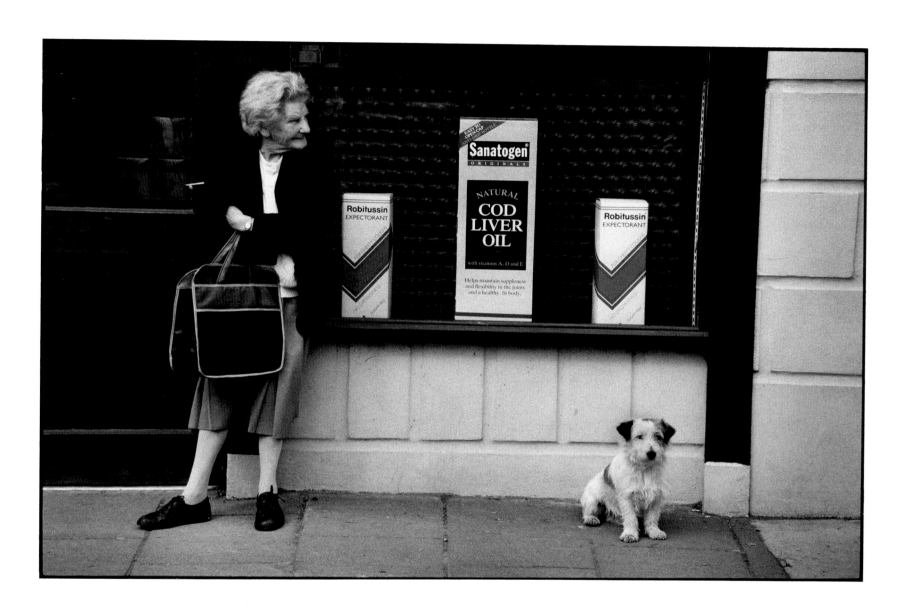

Cloyne, Eire, 1991

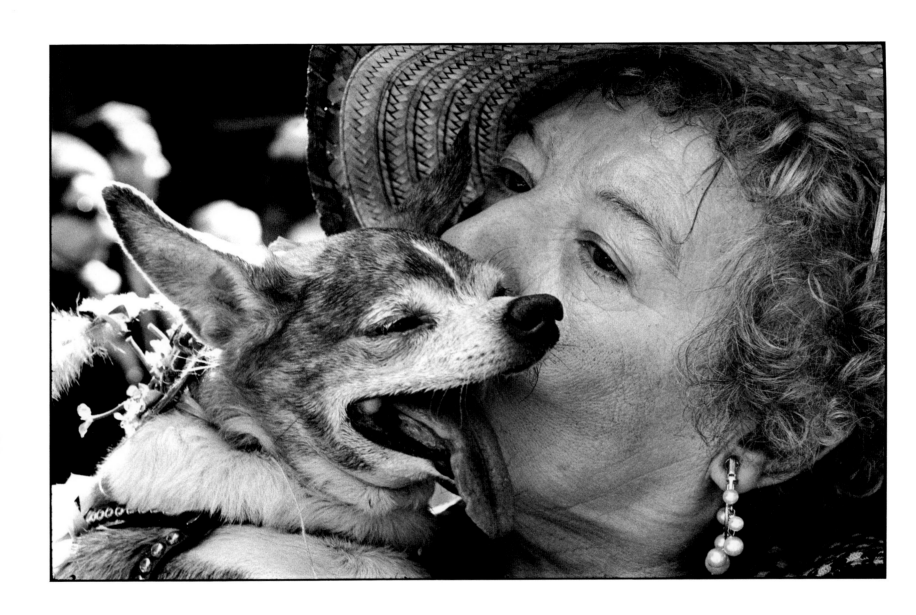

New York City, 1968

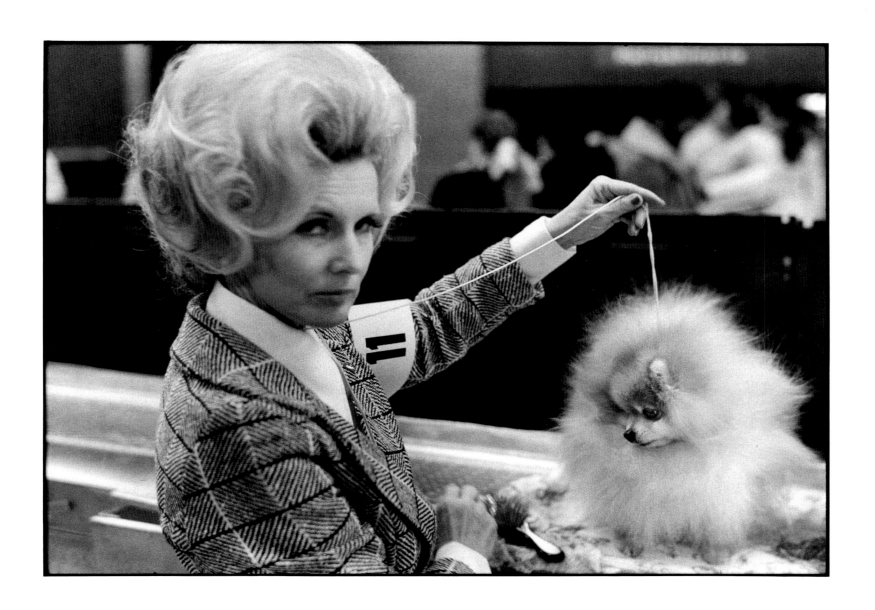

New York City, 1973

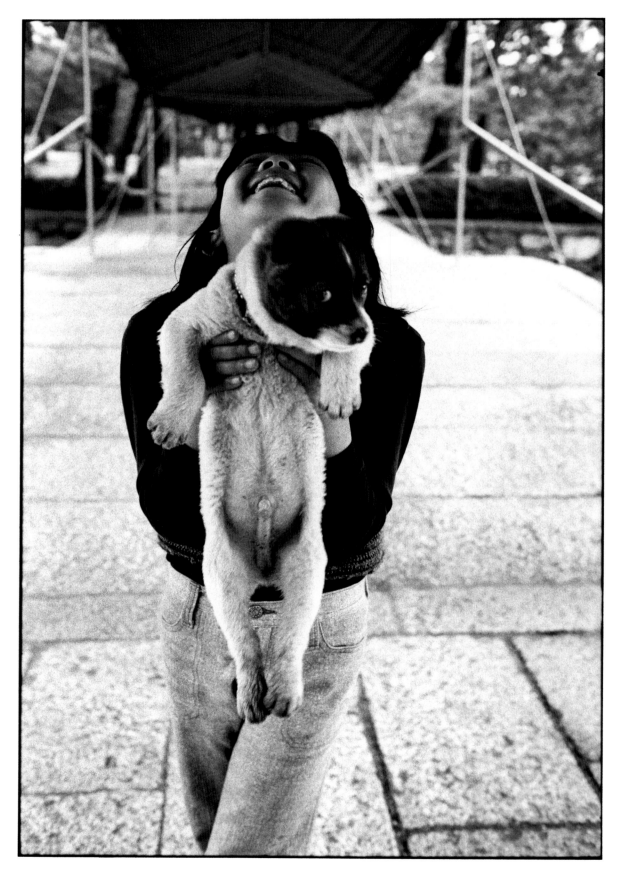

Kyoto, Japan, 1977

58

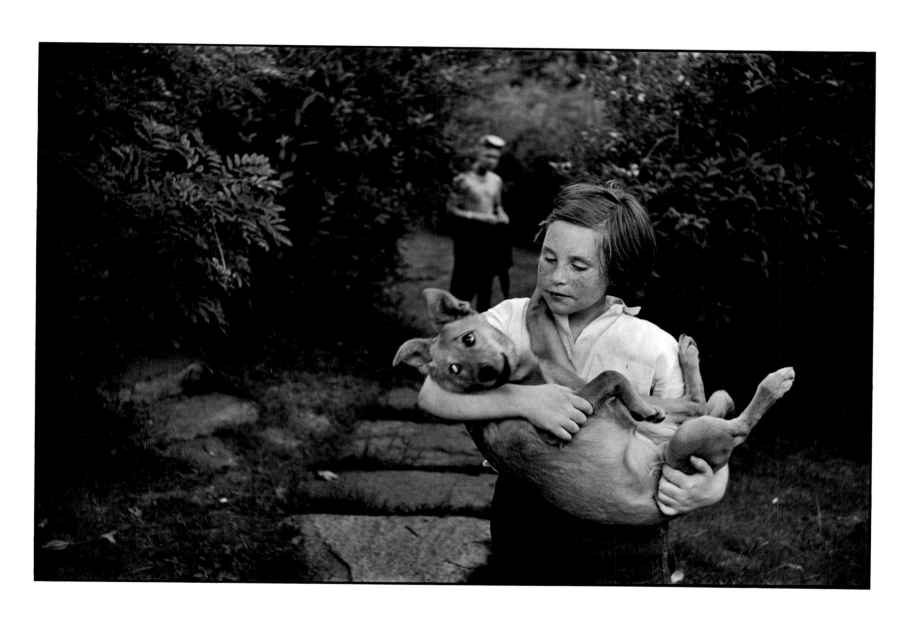

Armonk, New York, 1955

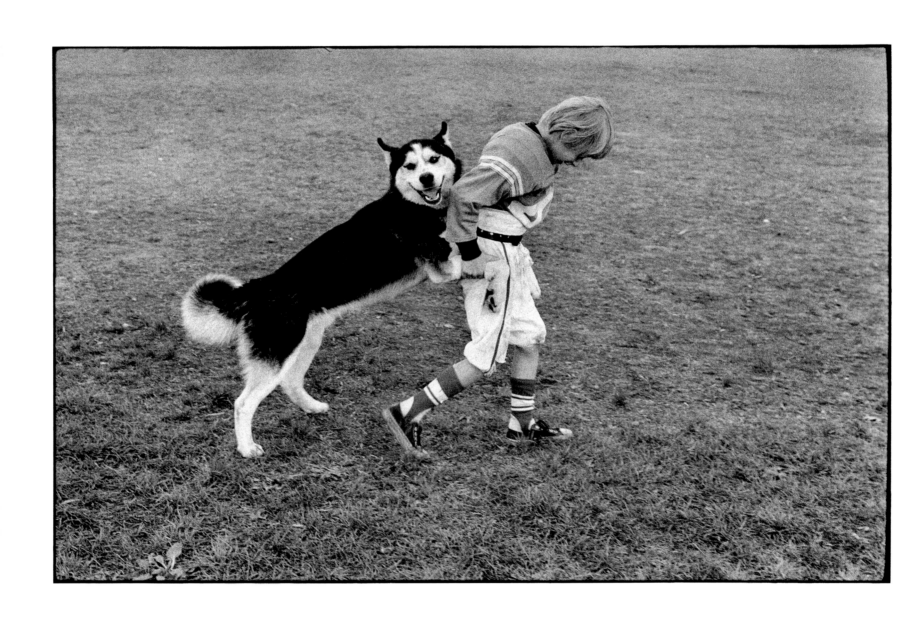

New York City, 1971

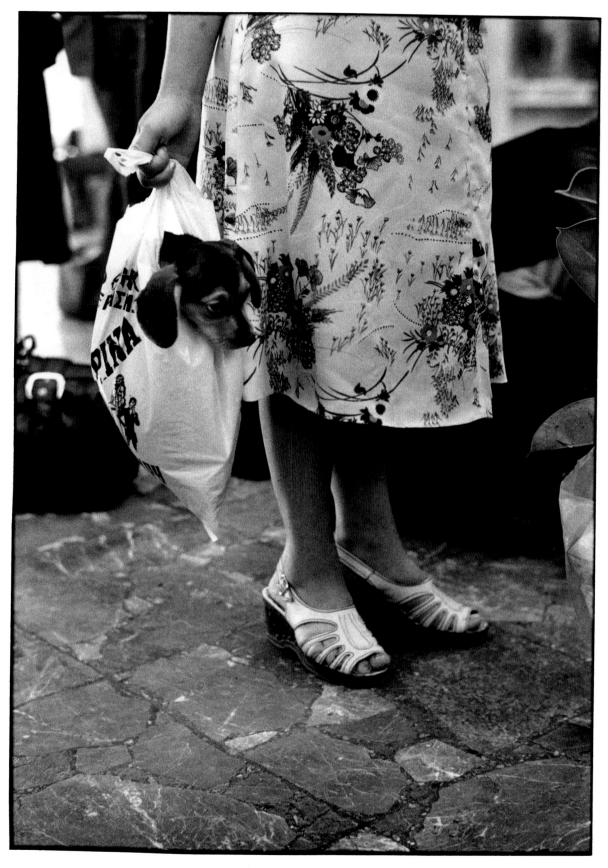

Athens, Greece, 1972

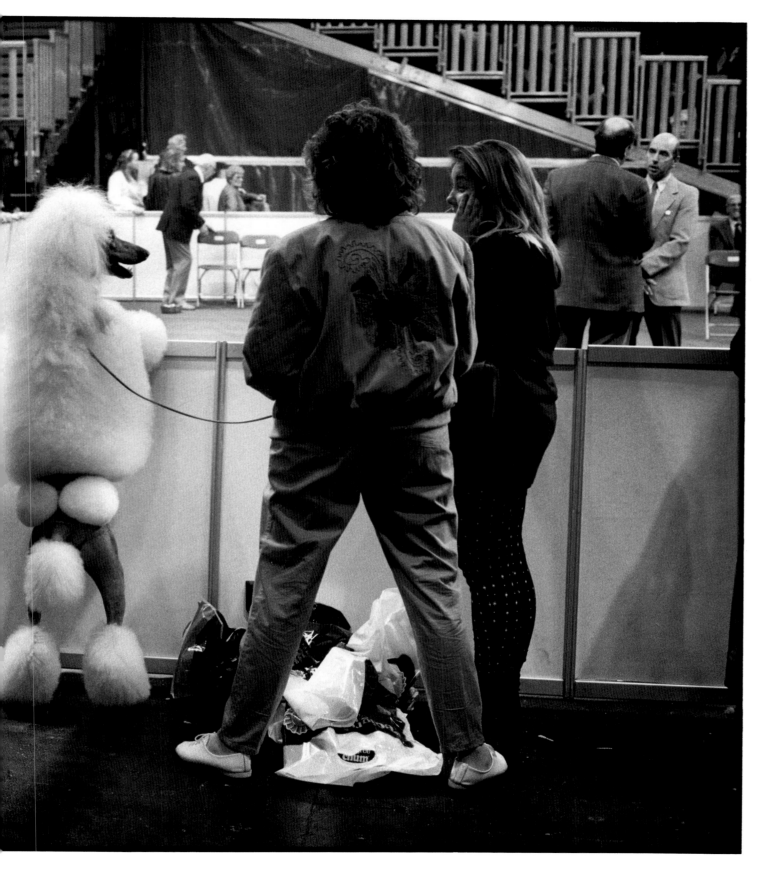

Birmingham, England, 1991

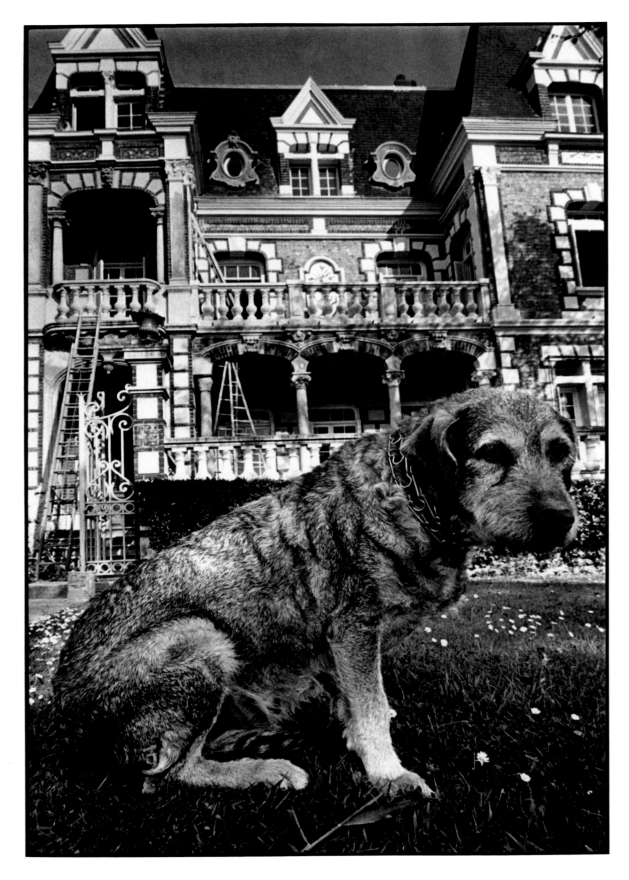

Trouville, France, 1965

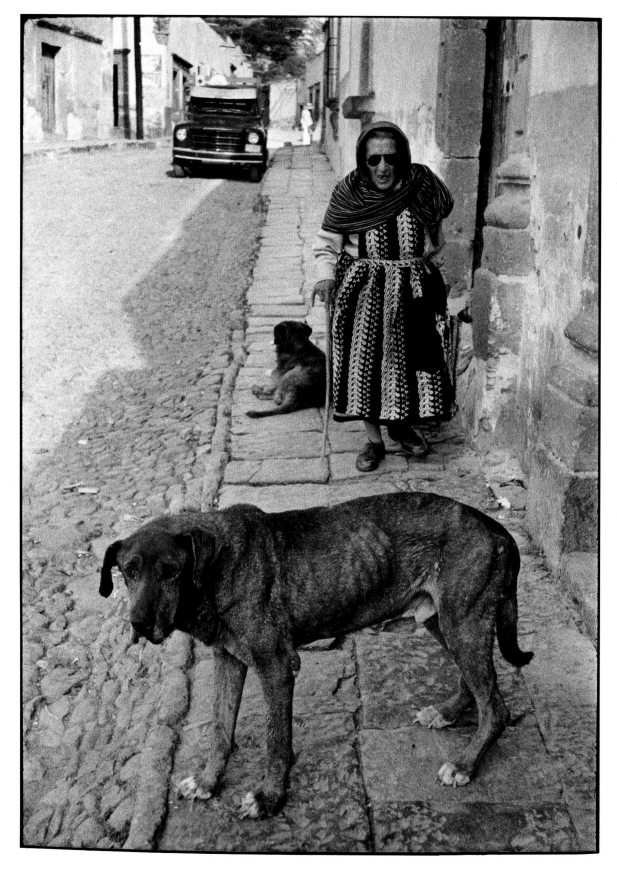

Mexico, 1956

65

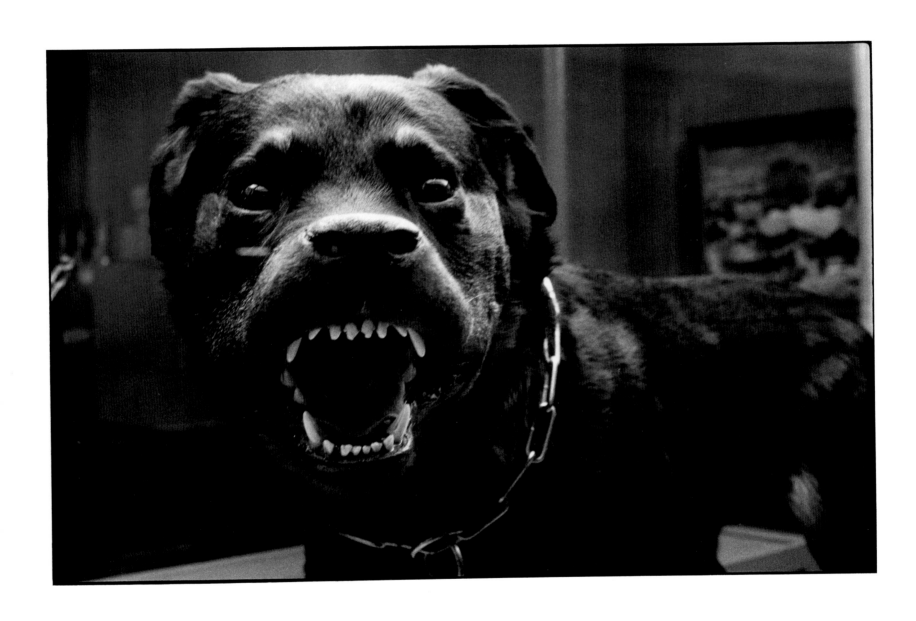

Birmingham, England, 1991

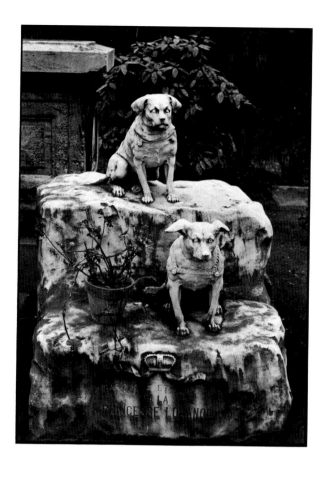

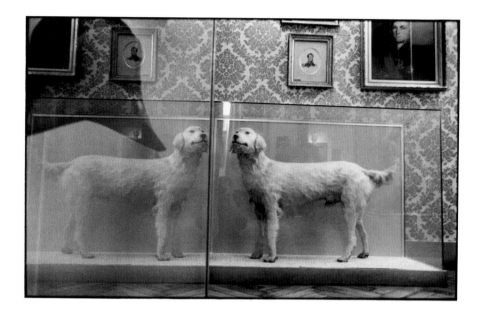

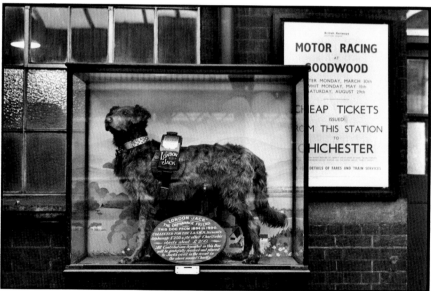

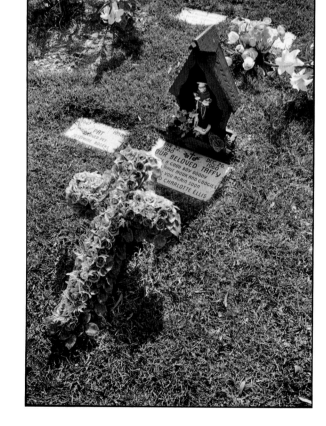

top left: Paris, 1973
top right: Paris, 1991
bottom left: England, 1964
bottom right: Los Angeles, 1962

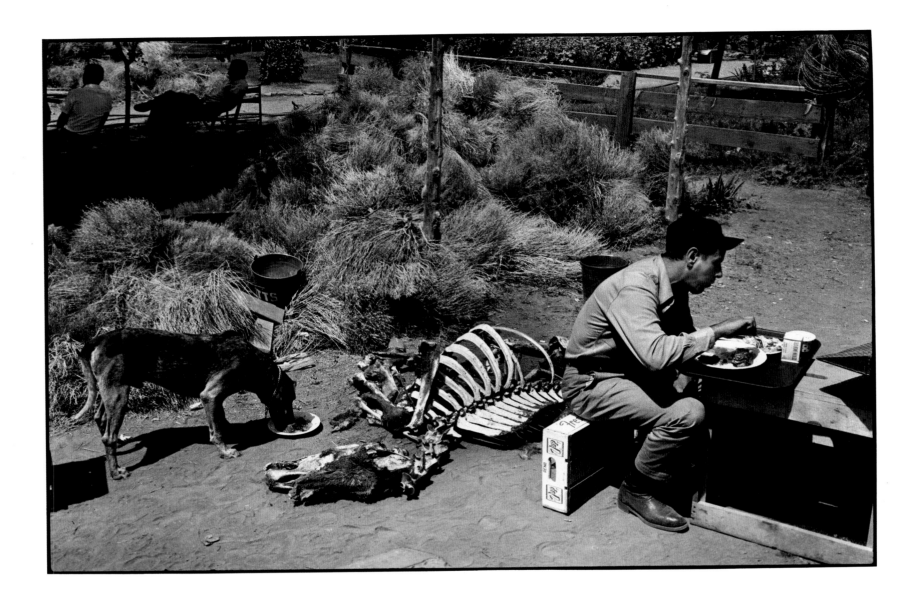

Reno, Nevada, 1960

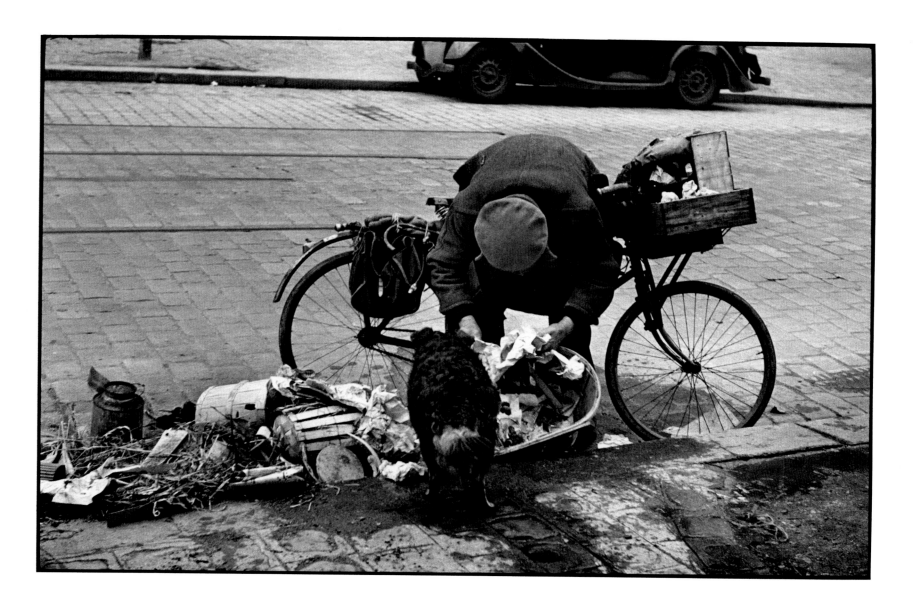

Paris, 1951

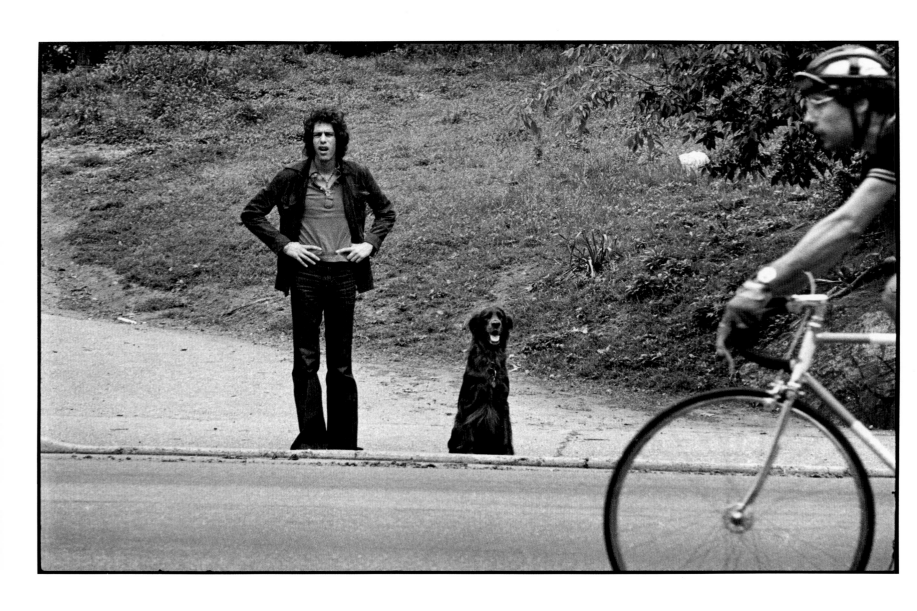

New York City, 1976

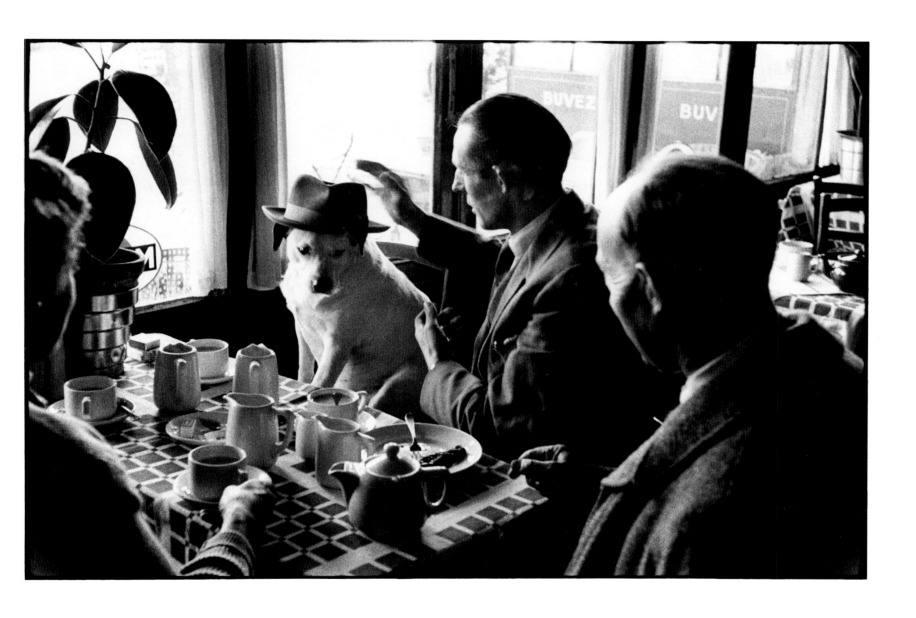

Brussels, Belgium, 1957

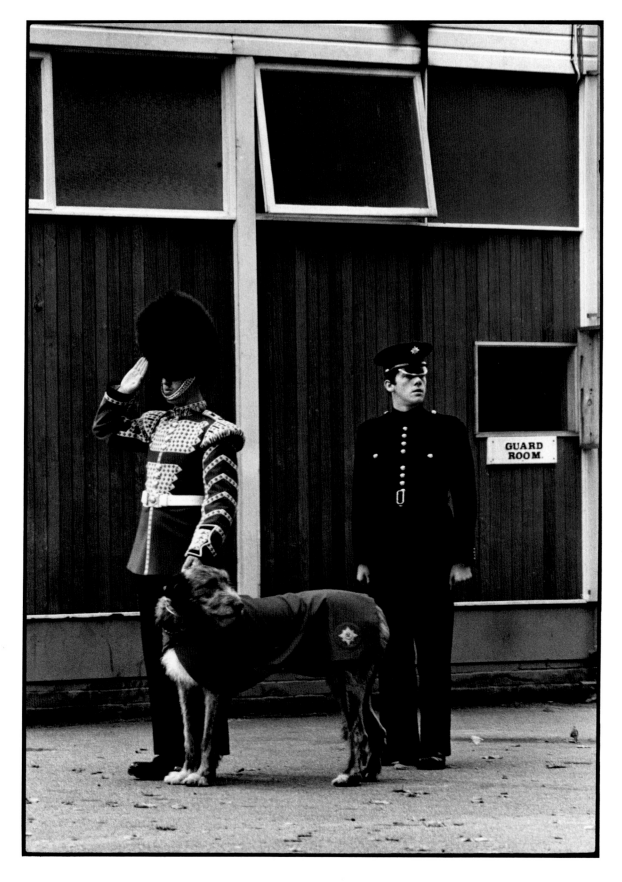

London, 1972

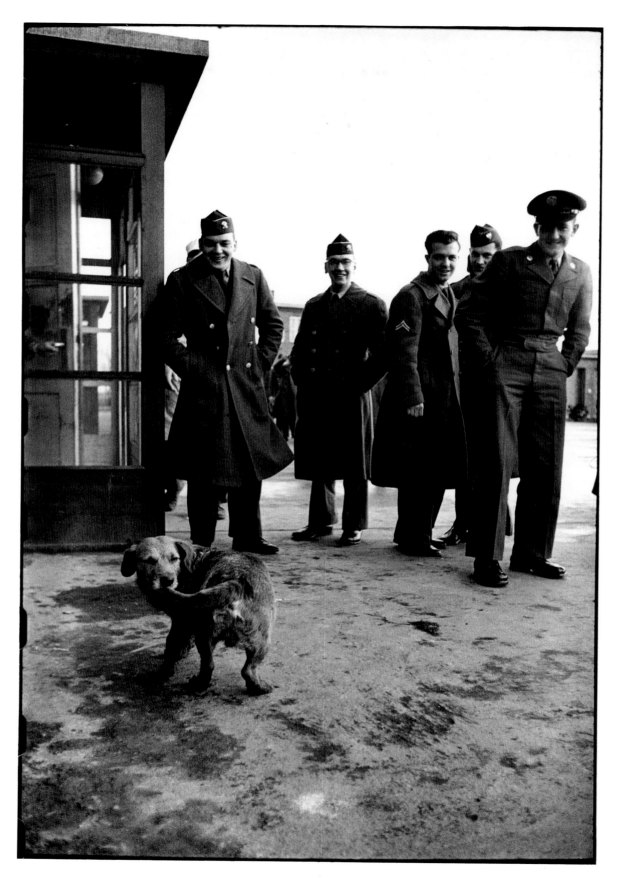

Orléans, France, 1952

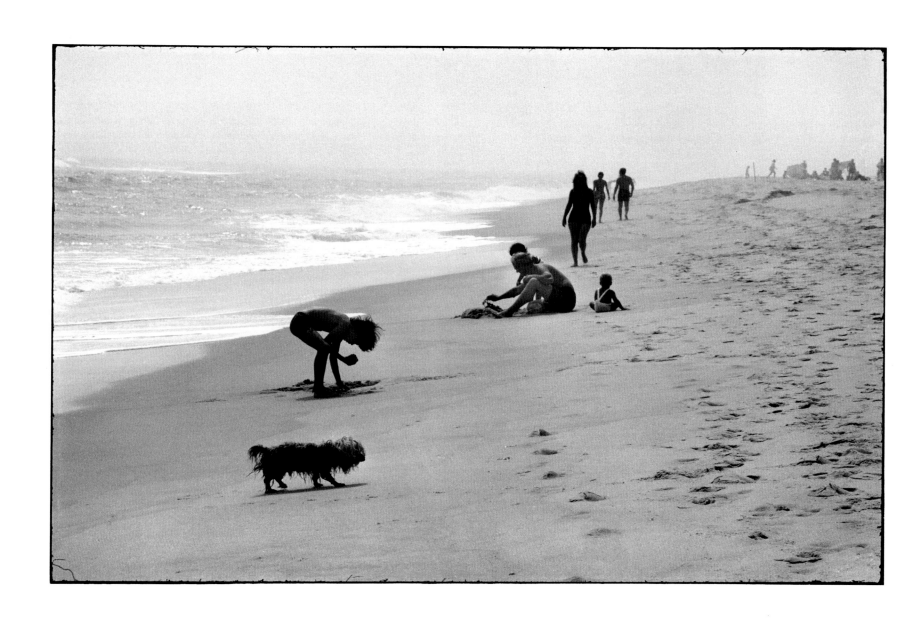

Southampton, New York, 1969

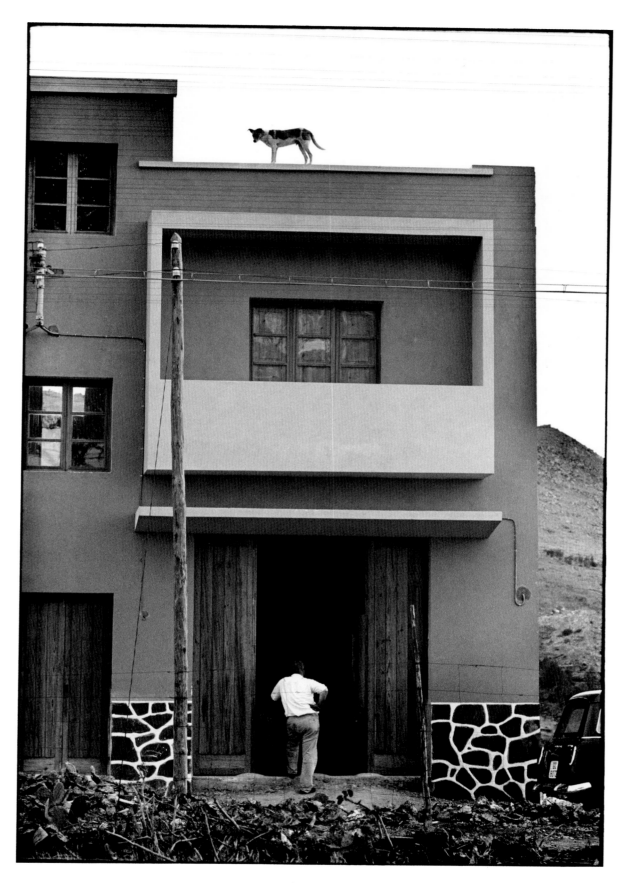

Las Palmas, Canary Islands, 1964

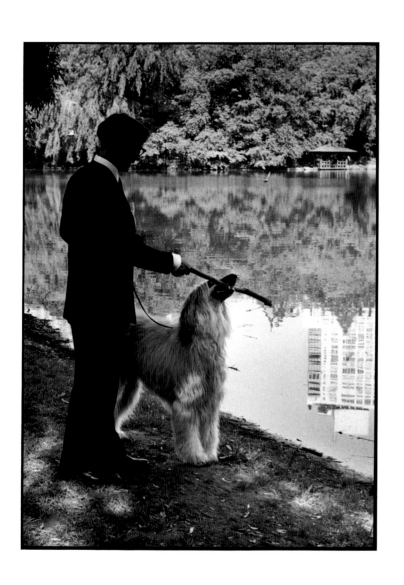
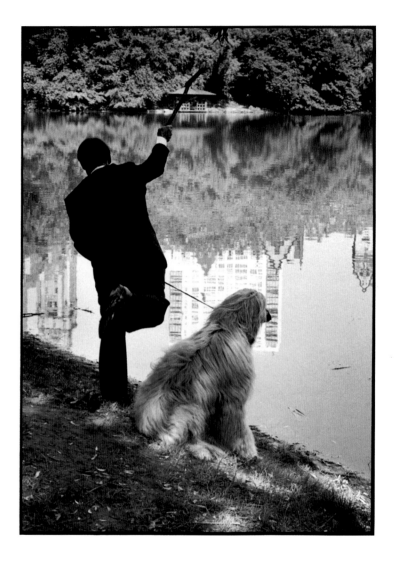

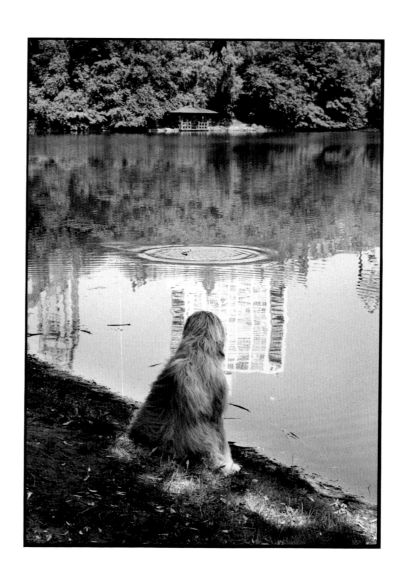

New York City, 1990

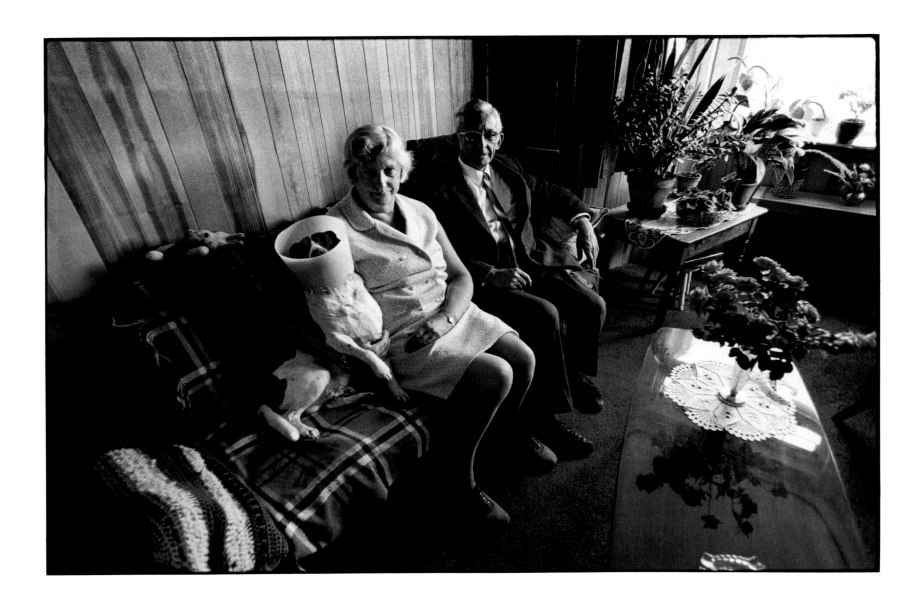

Holland, 1973

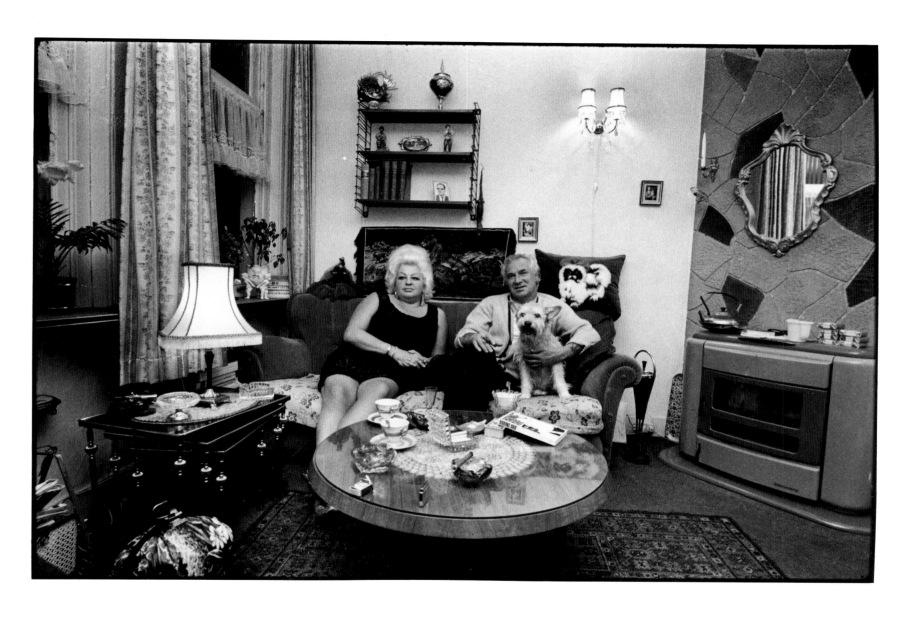

Amsterdam, 1968

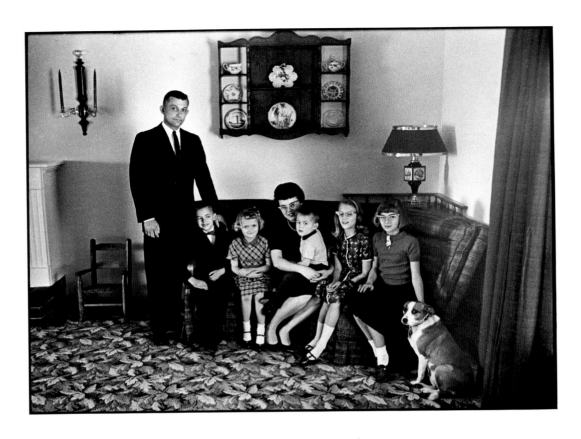

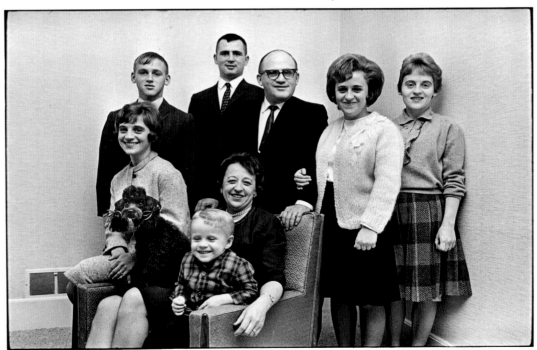

top: U.S.A., 1964

bottom: U.S.A., 1965

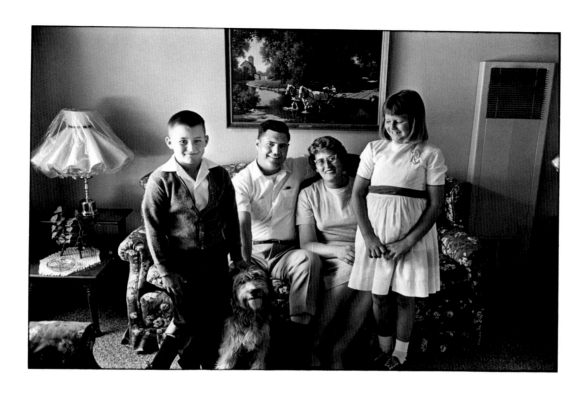

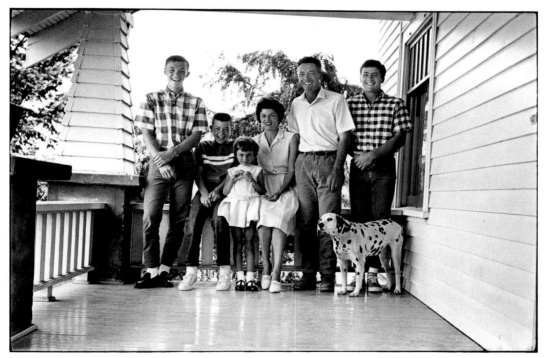

U.S.A., 1965

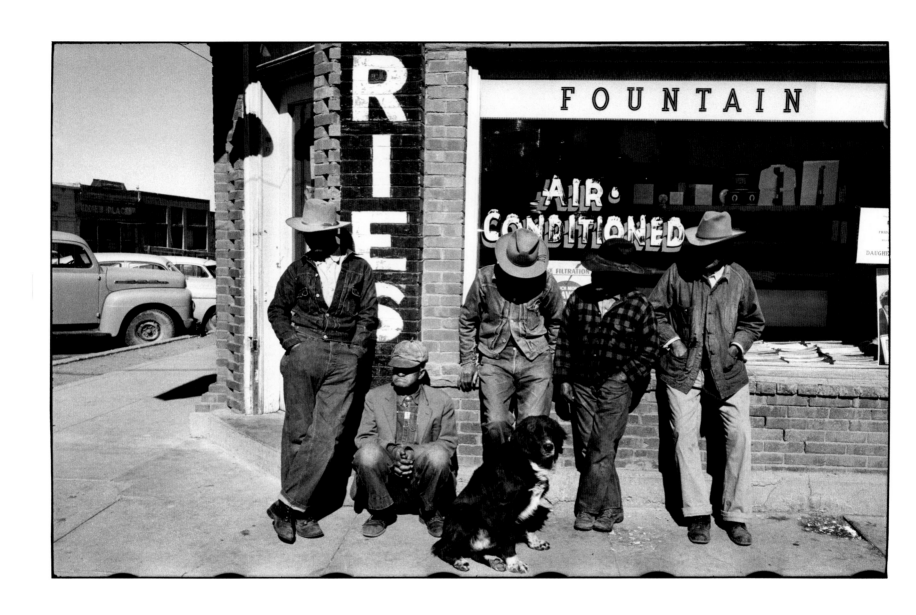

Colorado, 1954

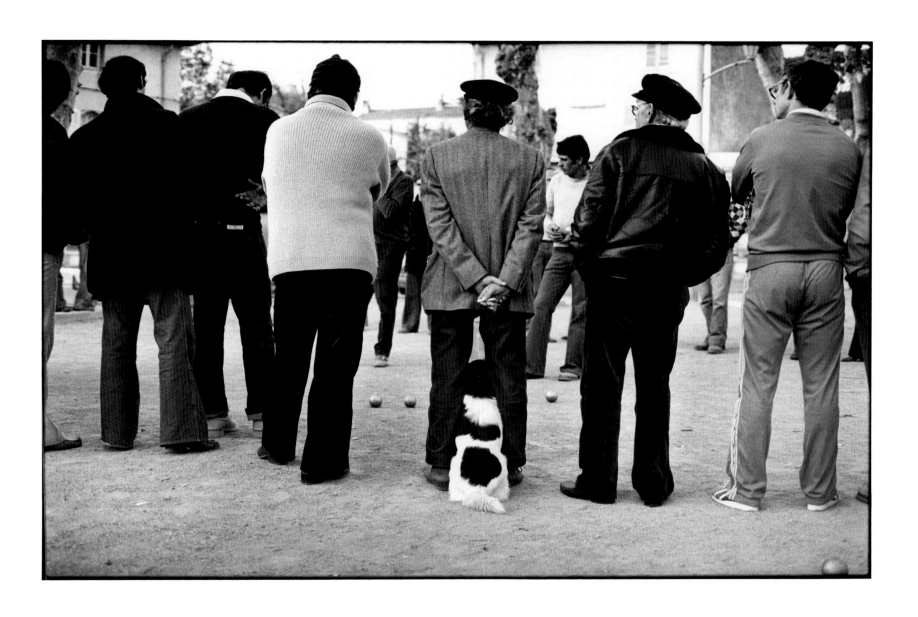

Saint Tropez, 1979

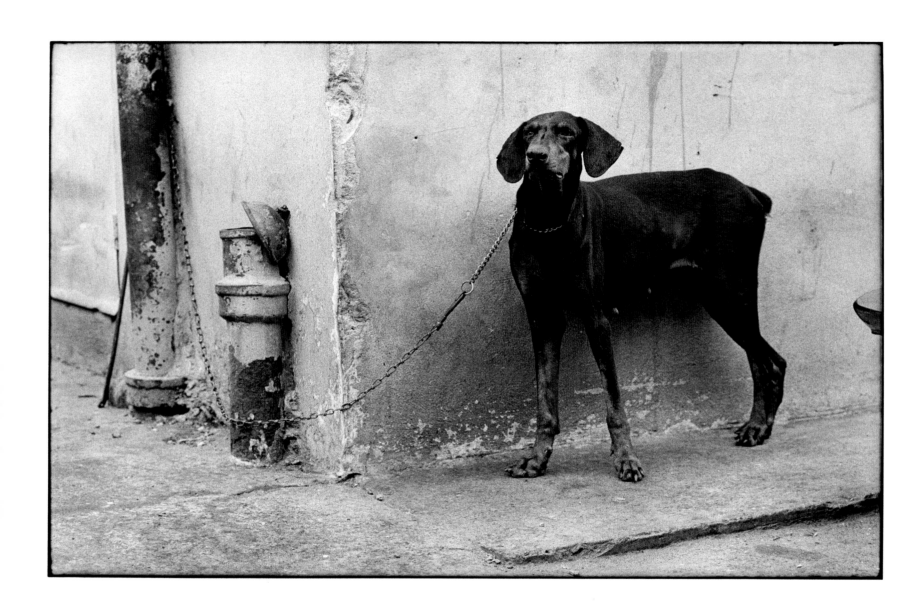

San Juan, Puerto Rico, 1969

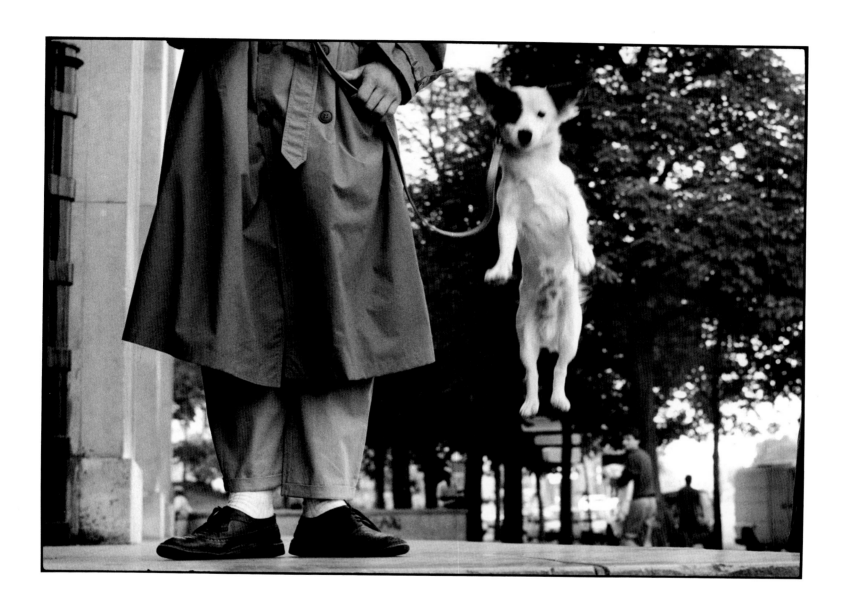

Paris, 1989

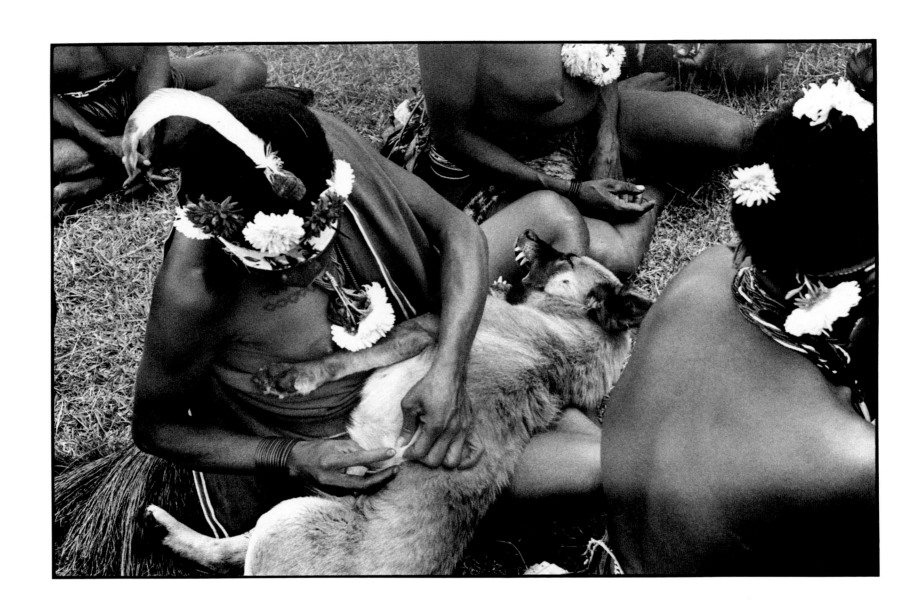

New Guinea, 1961

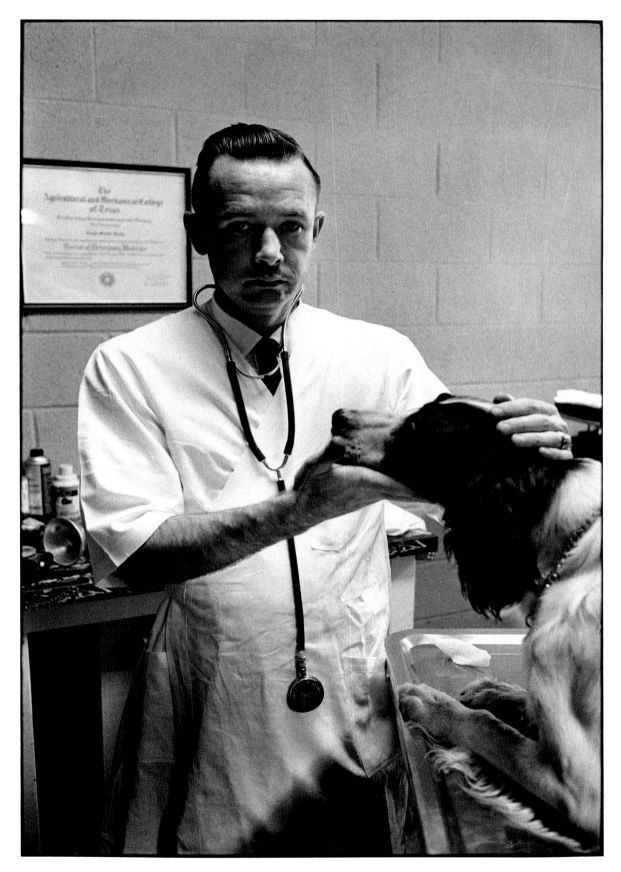

U.S.A., 1962

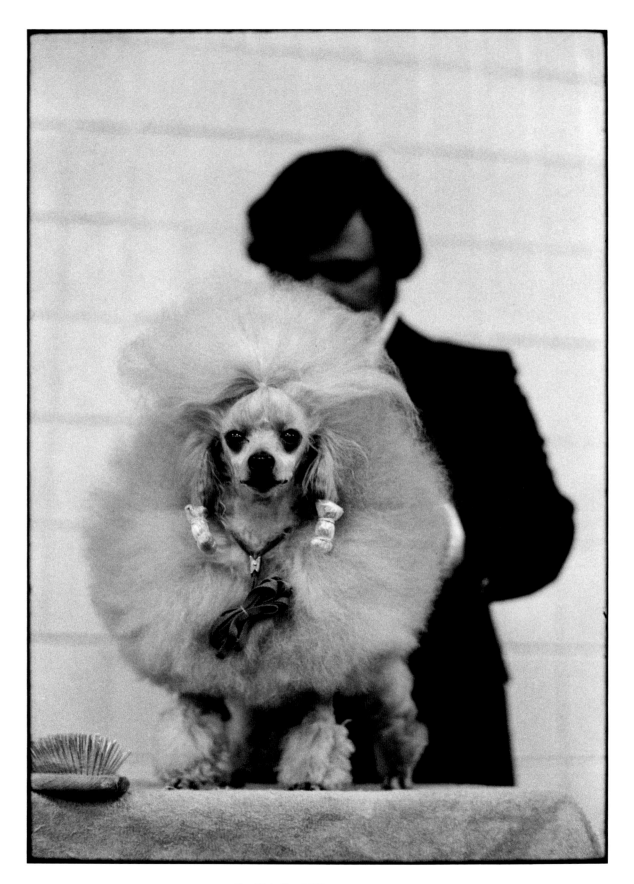

New York City, 1973

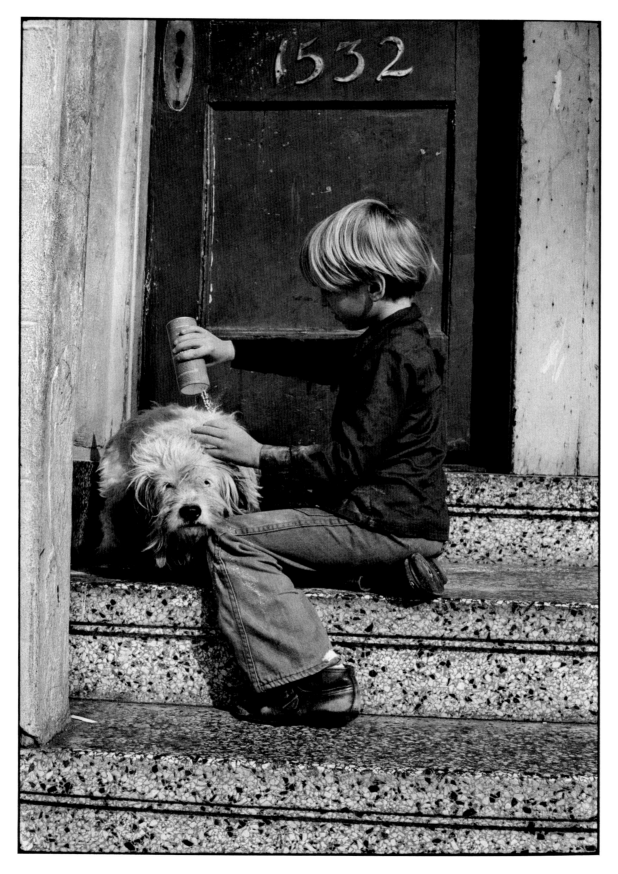

San Francisco, 1972

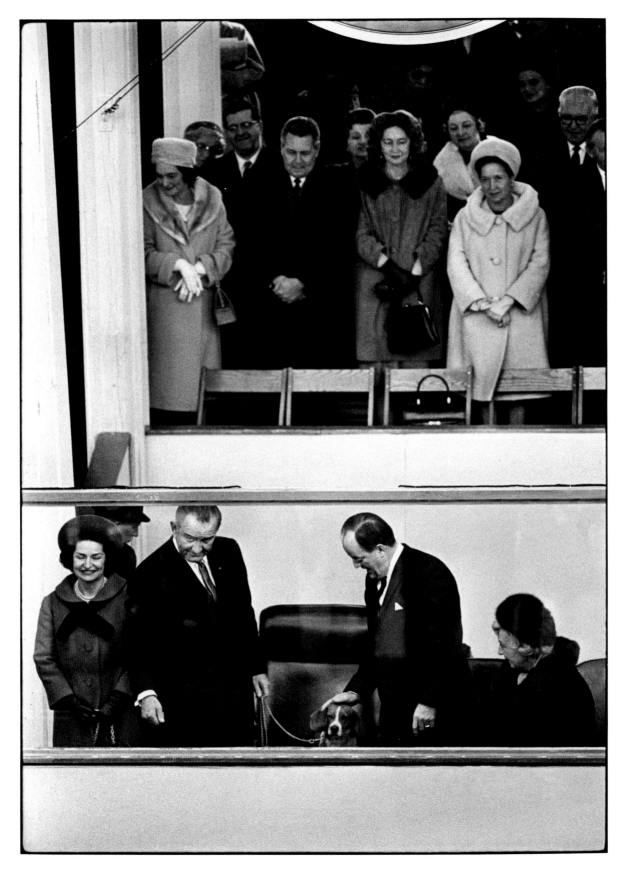

Washington, D.C., 1965

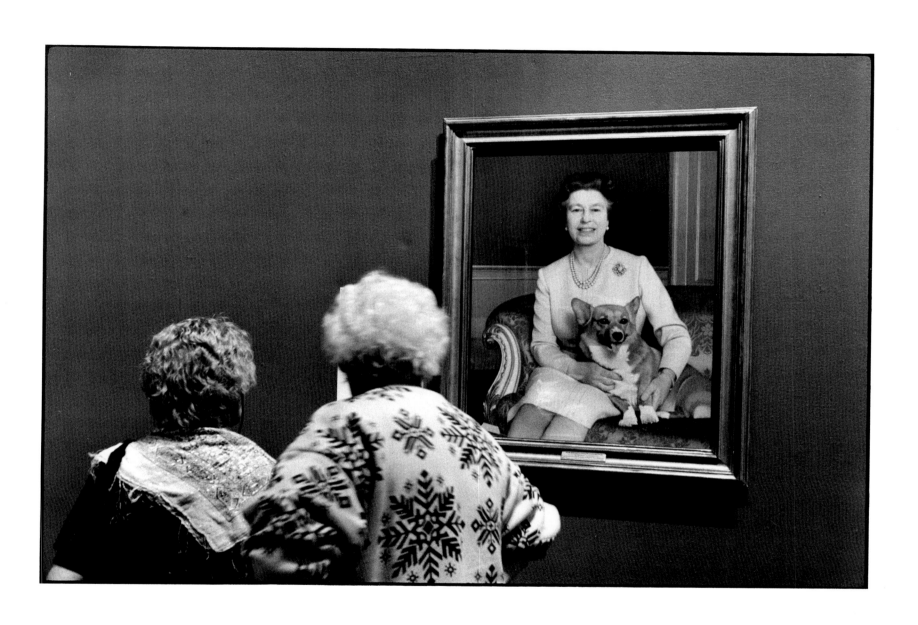

Birmingham, England, 1991

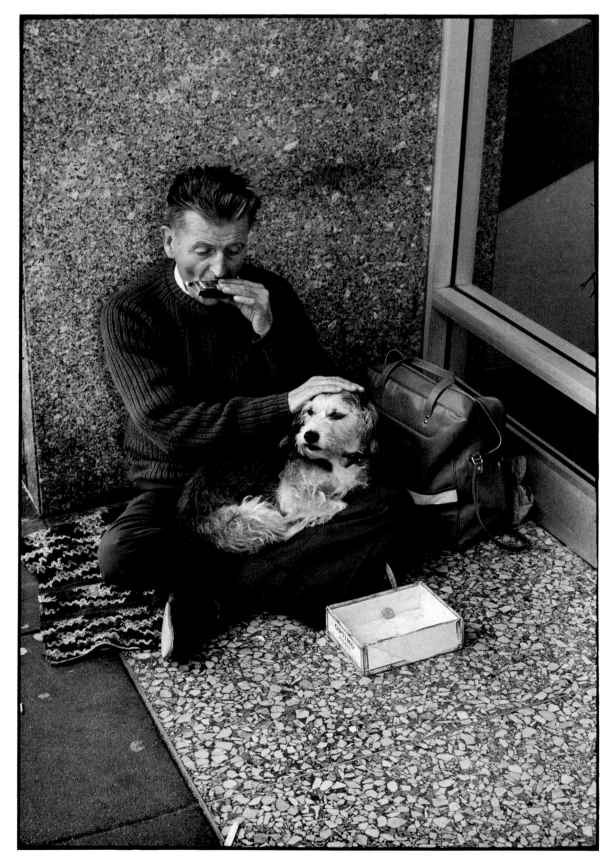

San Francisco, 1976

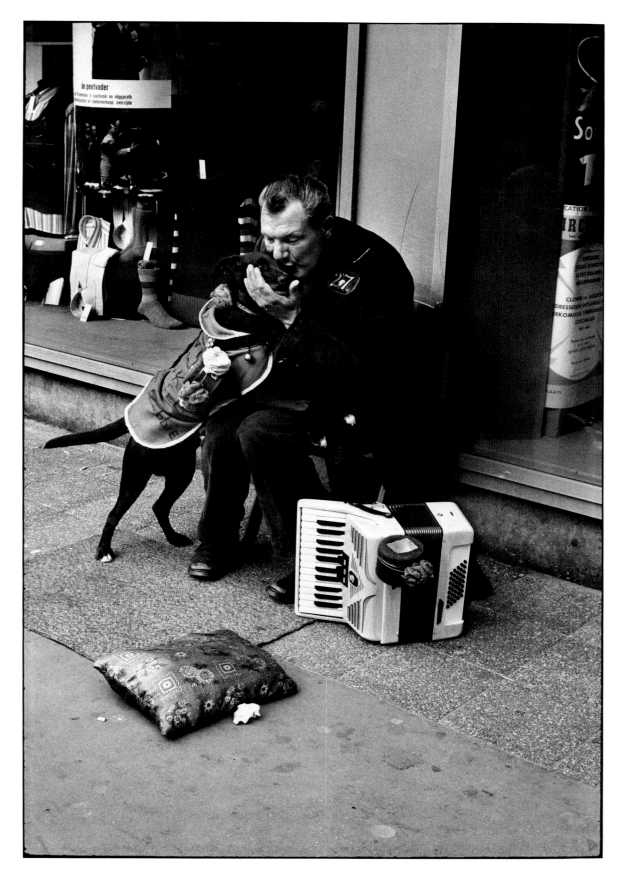

Amsterdam, 1972

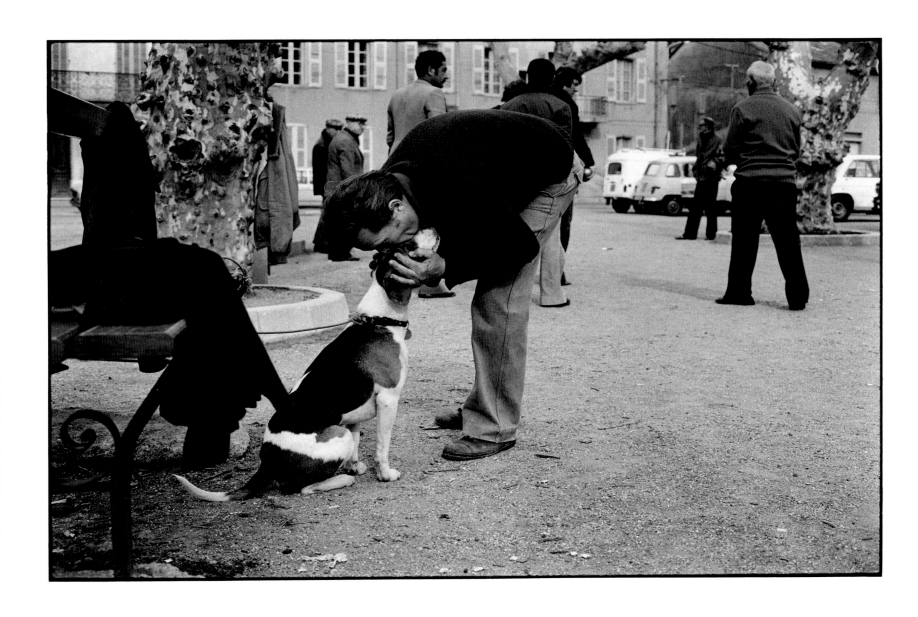

Saint Tropez, 1979

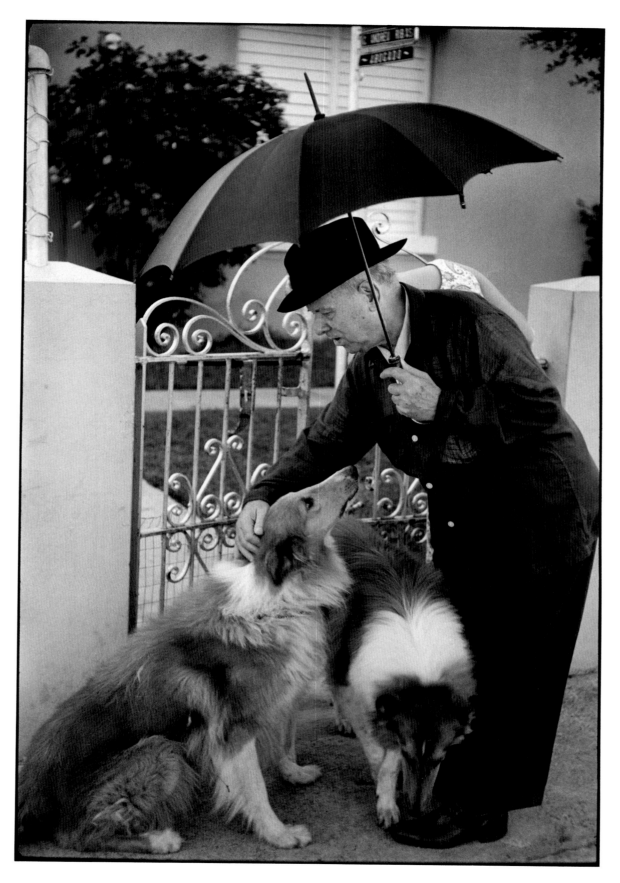

San Juan, Puerto Rico, 1957

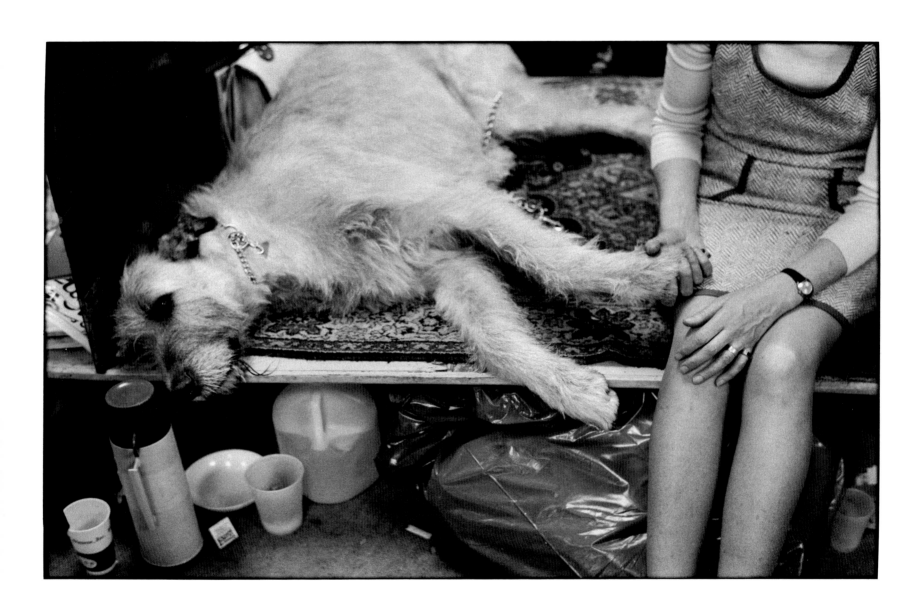

New York City, 1973

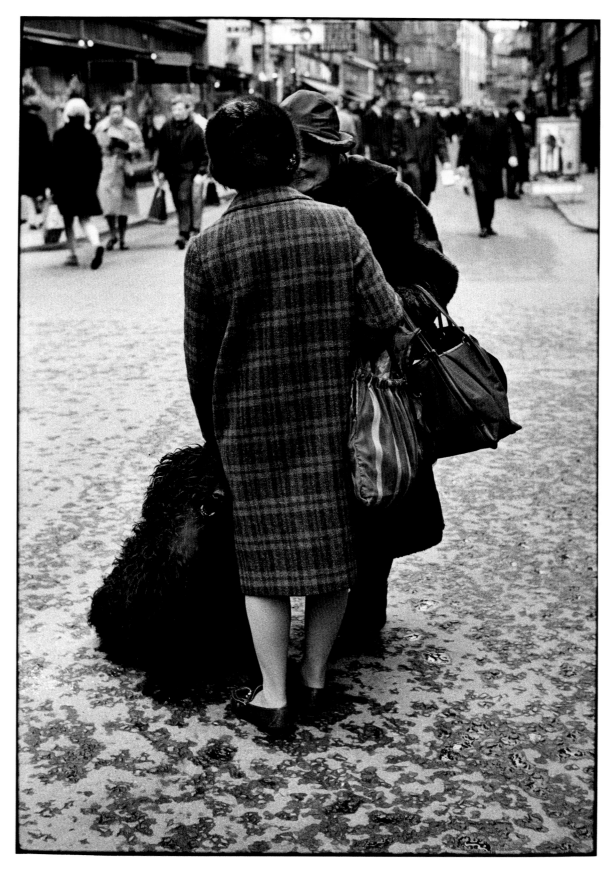

Copenhagen, 1968

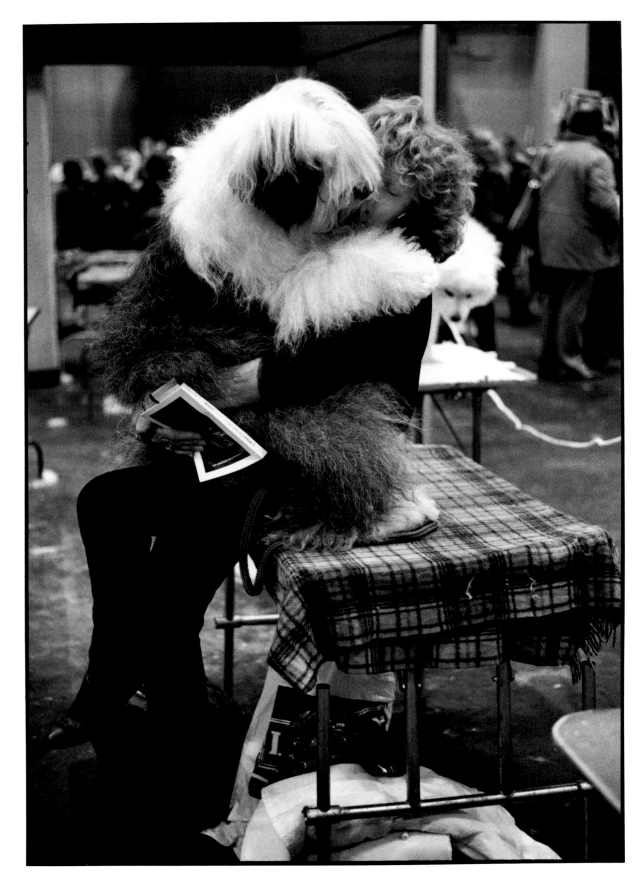

Birmingham, England, 1991

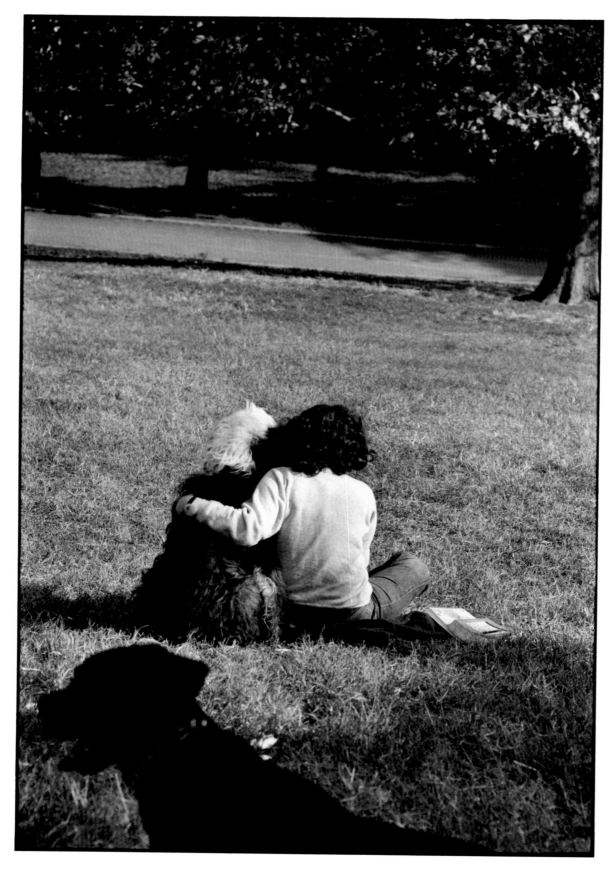

New York City, 1972

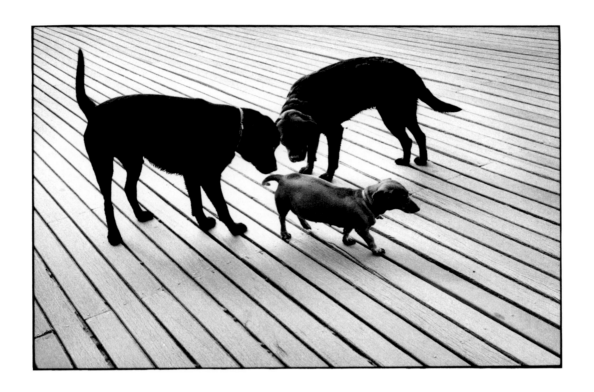

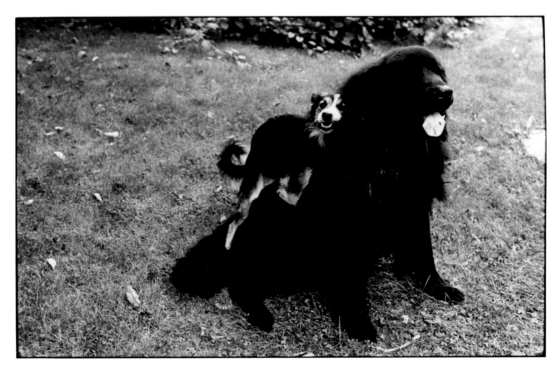

top: Deauville, France, 1991
bottom: Amagansett, New York, 1967

100

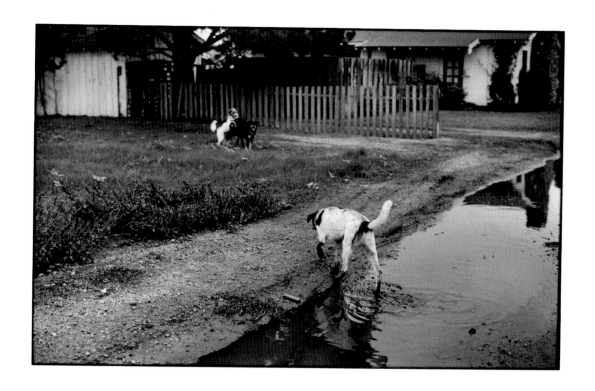

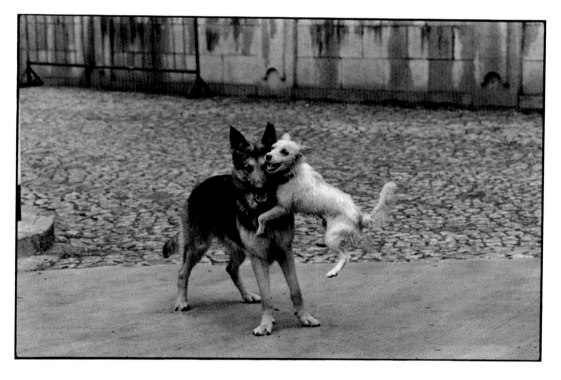

top: California, 1972
bottom : Macao, 1986

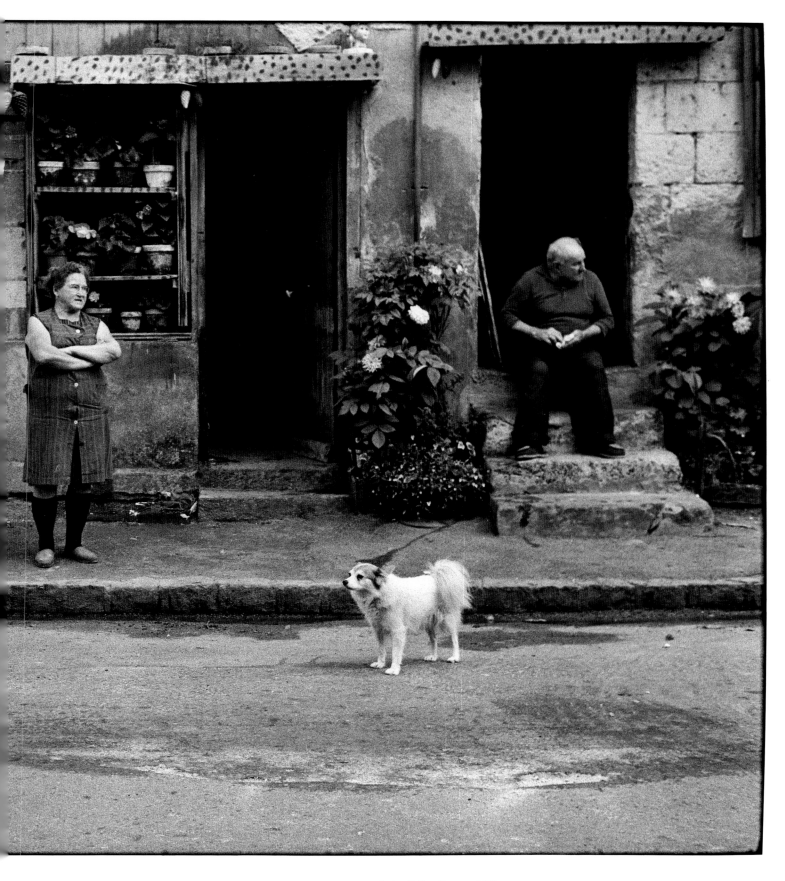

Loire Valley, France, 1972

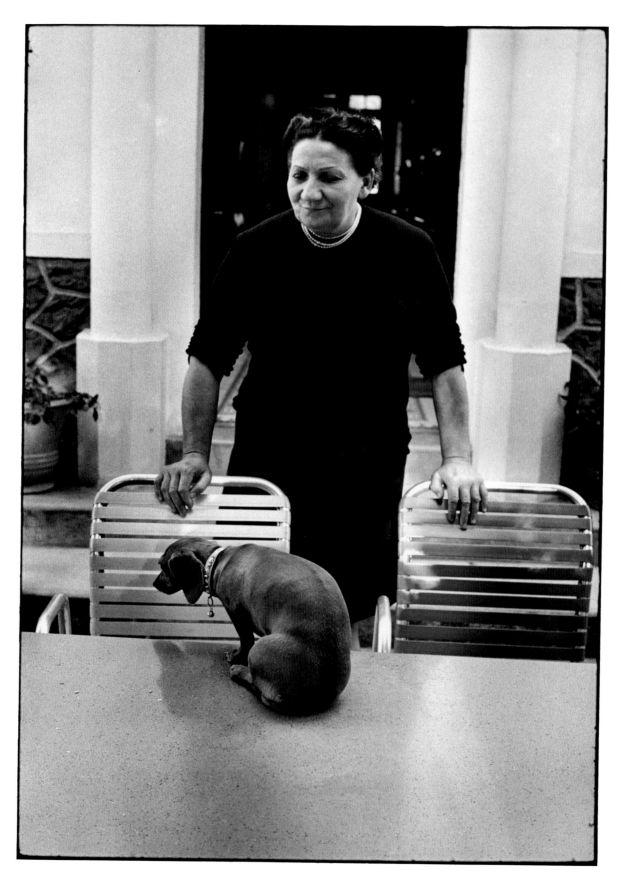

France, 1968

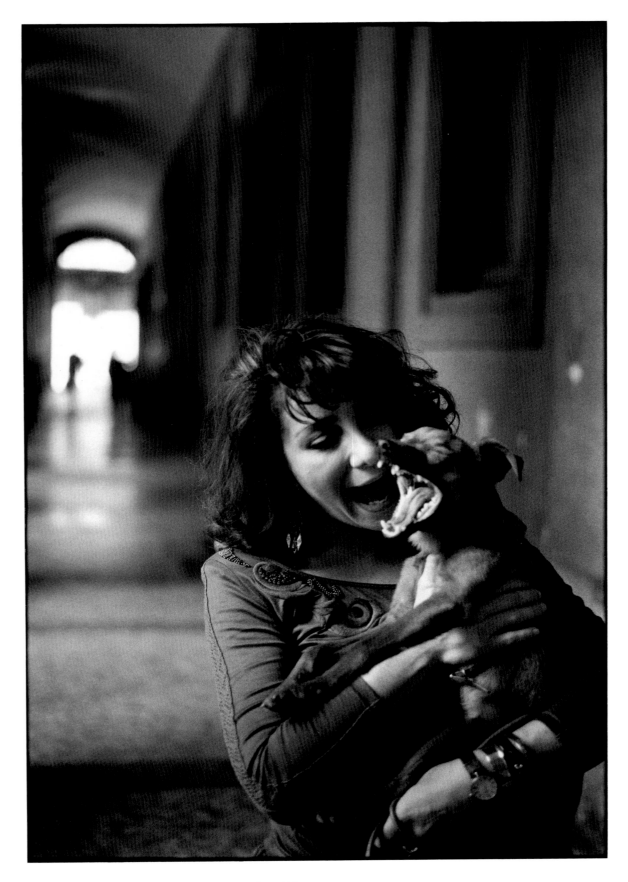

Milan, 1990

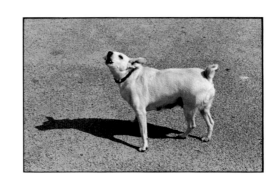

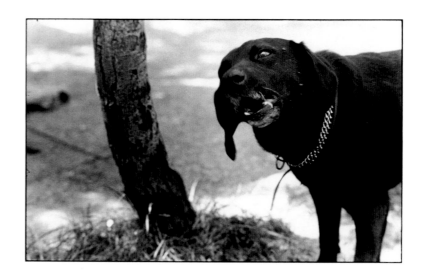

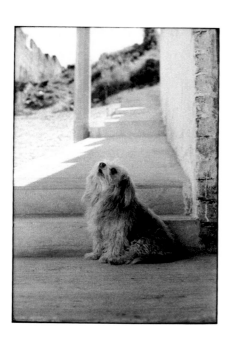

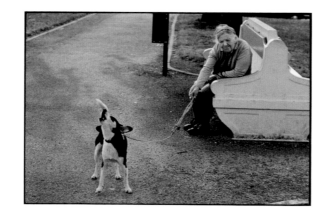

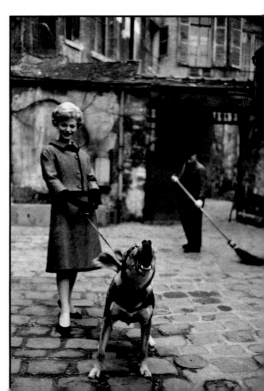

top left: Cannes, 1980
top right: Honfleur, France, 1968
middle left: San Francisco, 1979
middle right: Saint Tropez, 1978
bottom left: Puerto Vallarta, Mexico, 1973
bottom middle: Versailles, 1975
bottom right: Paris, 1958

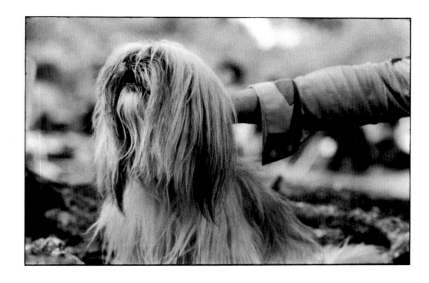

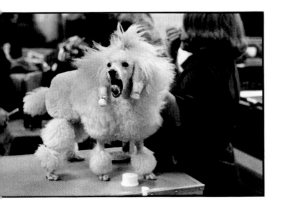

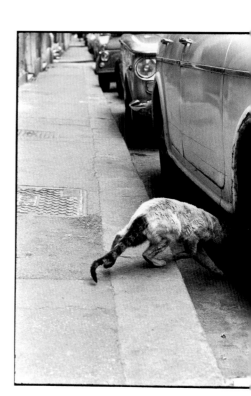

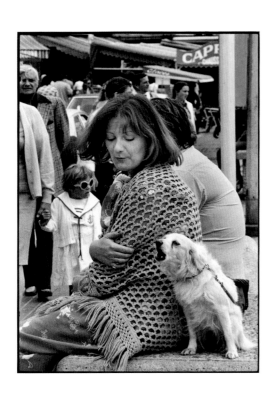

top left: Tokyo, 1985
top right: California, 1975
middle left: New York City, 1973
middle middle: Trevi Gardens, Italy, 1969
middle right: Rome, 1969
bottom left: Saint Tropez, 1979

107

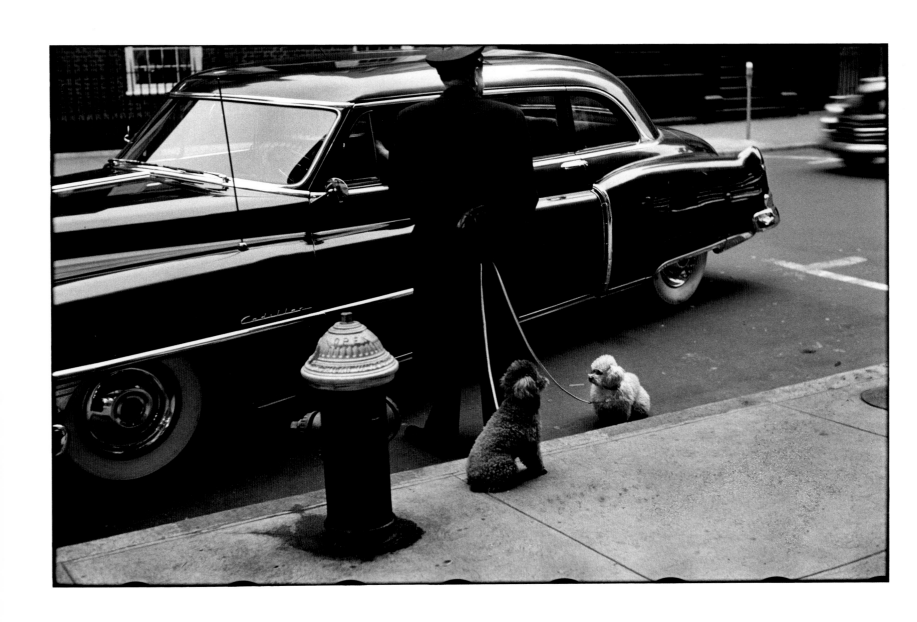

New York City, 1953

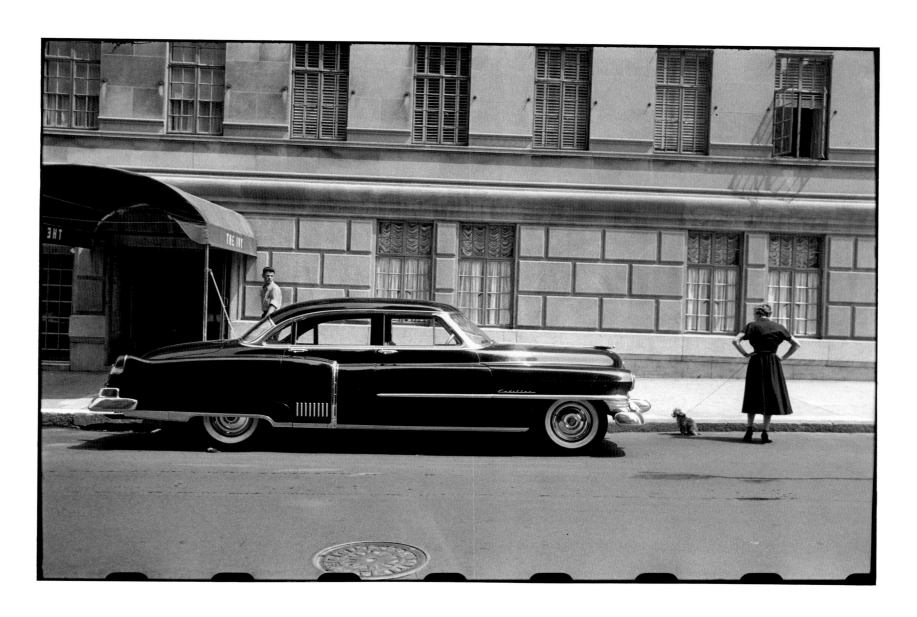

New York City, 1953

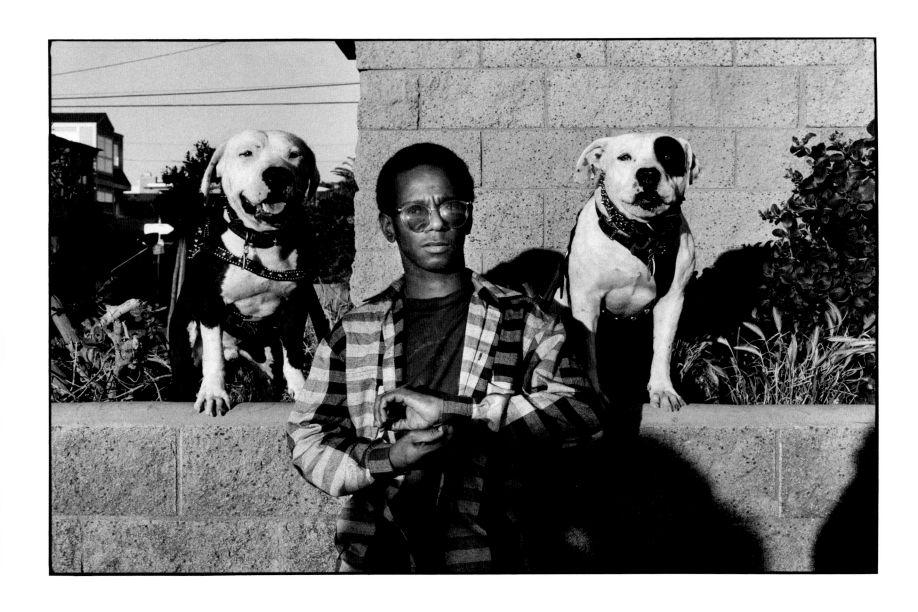

Venice, California, 1986

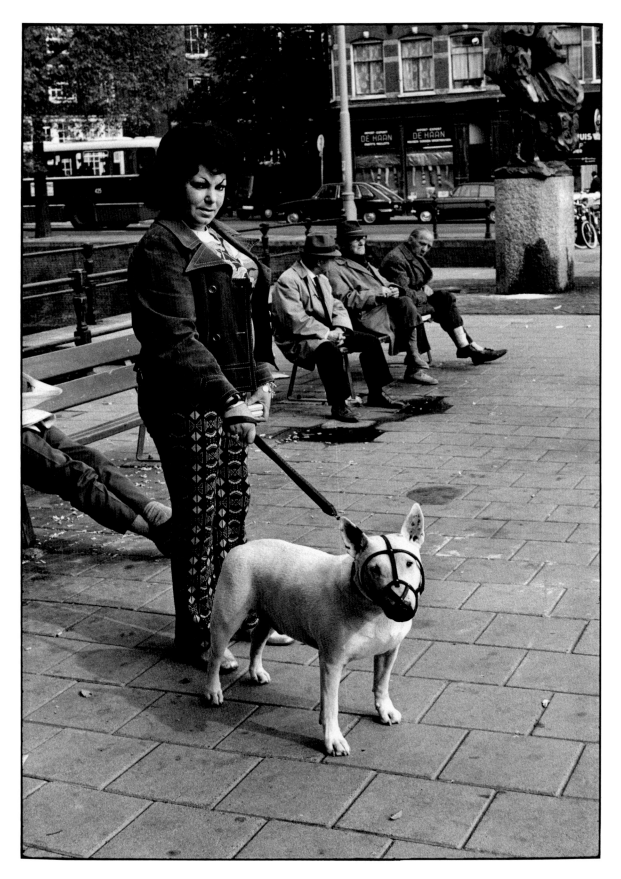

Amsterdam, 1972

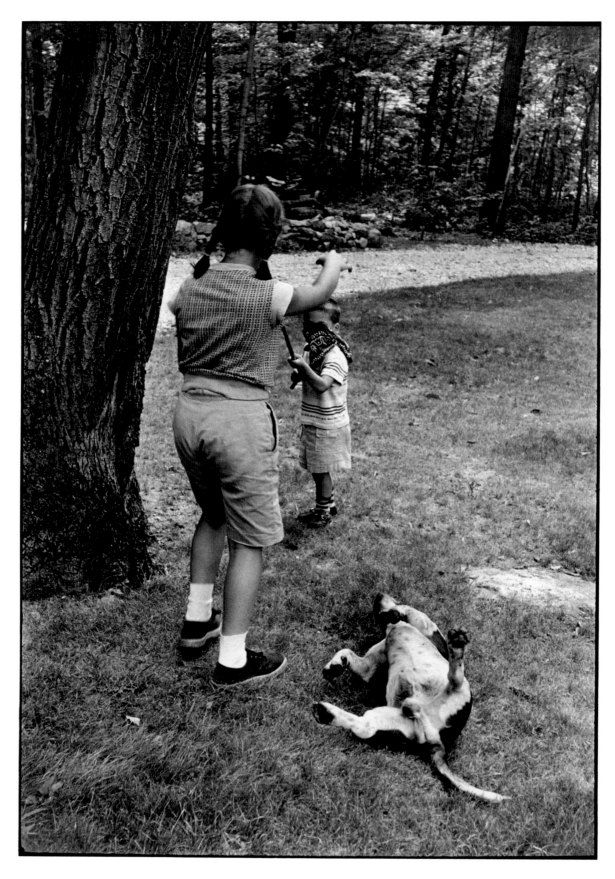

Armonk, New York, 1959

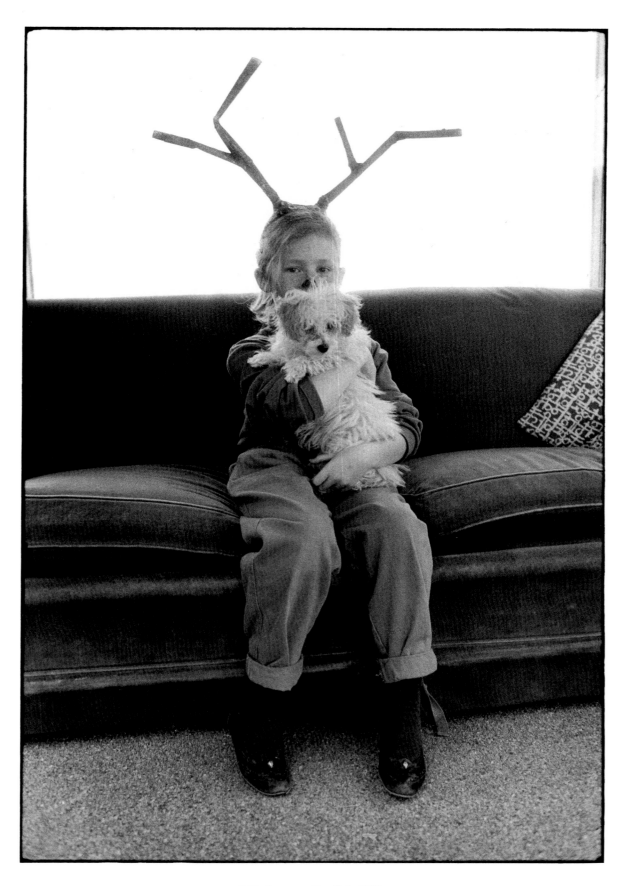

Bridgehampton, New York, 1959

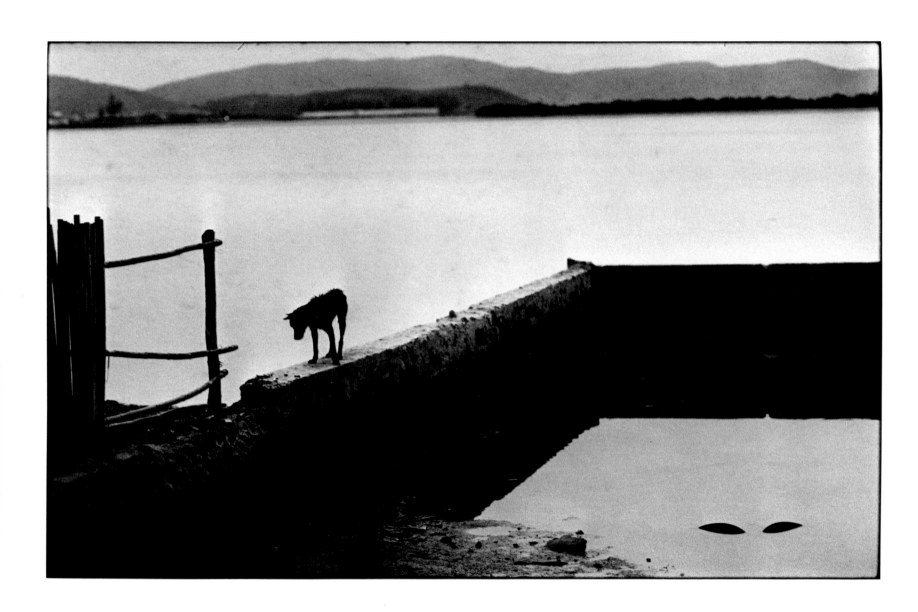

Brazil, 1963

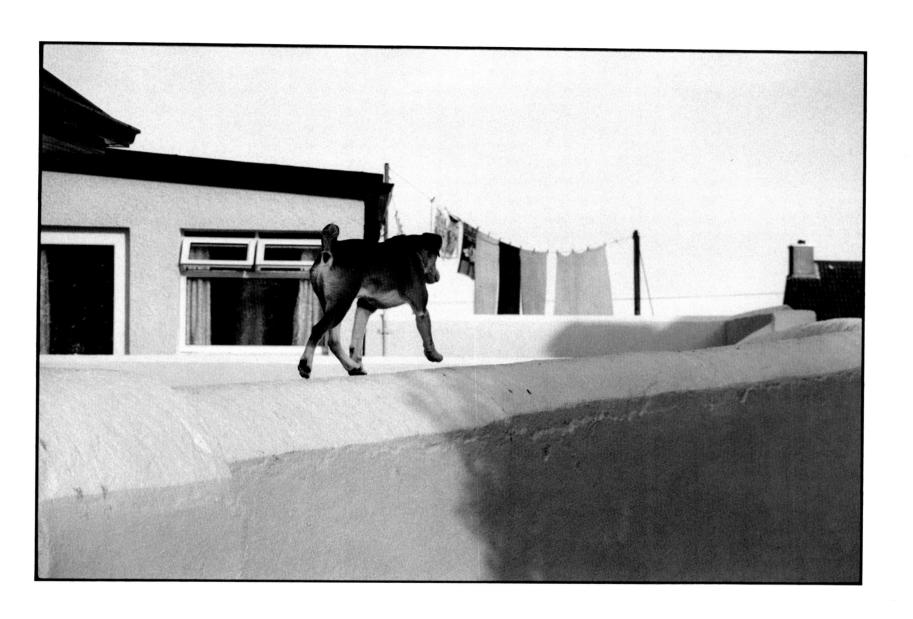

Ballycotton, Eire, 1991

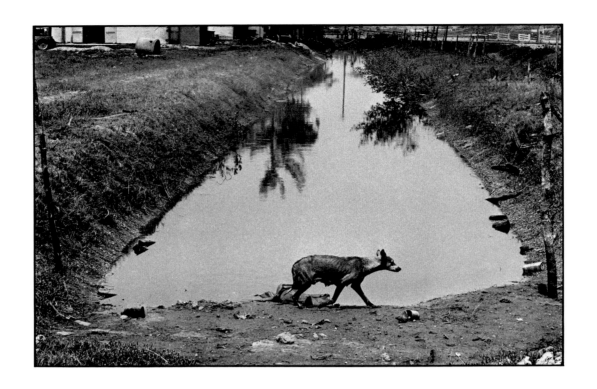

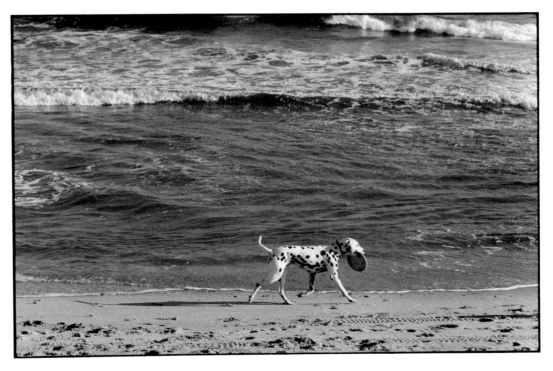

top: Cabo Frio, Brazil, 1965
bottom: East Hampton, New York, 1987

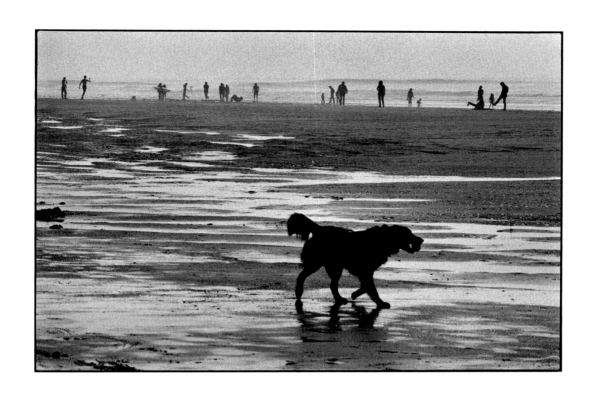

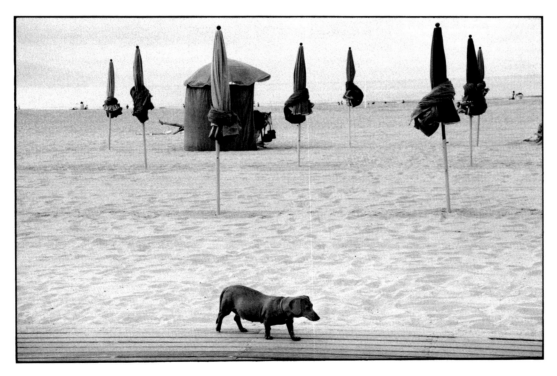

top: San Francisco, 1982
bottom: Deauville, France, 1991

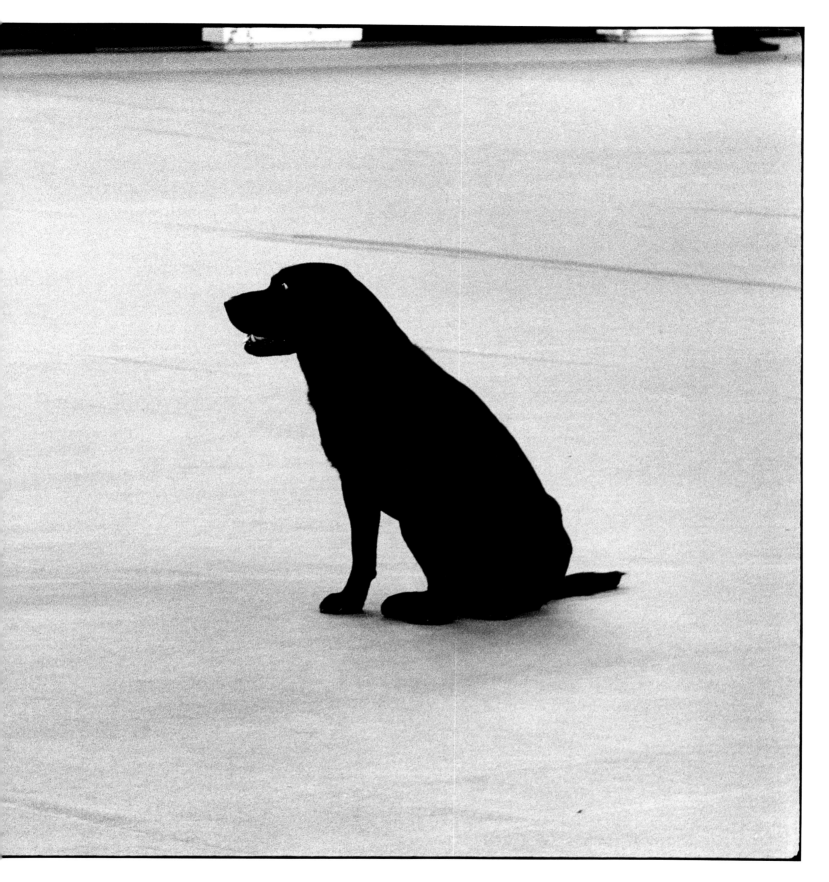

Birmingham, England, 1991

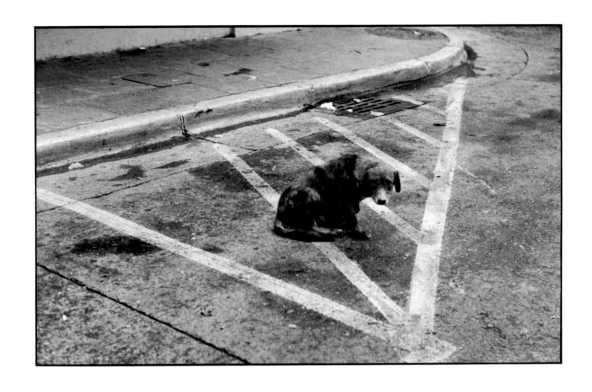

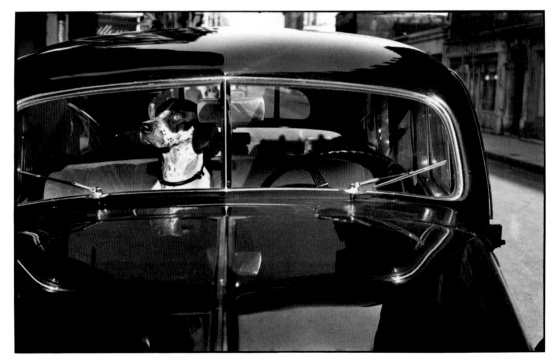

top: San Juan, Puerto Rico, 1978
bottom: Paris, 1951

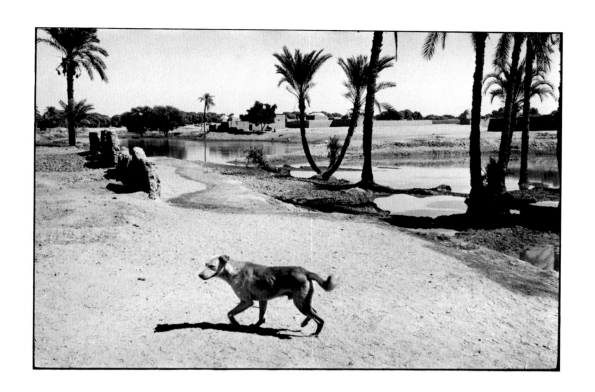

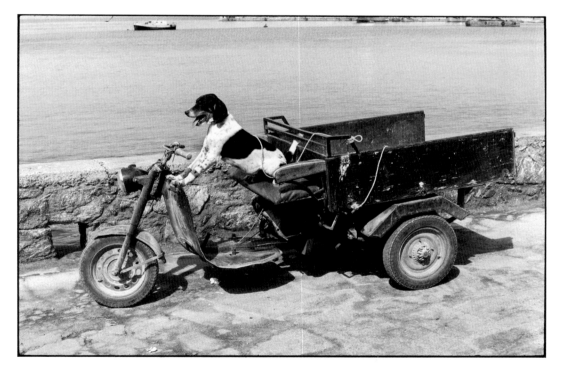

top: Luxor, Egypt, 1958
bottom: Mikonos, Greece, 1976

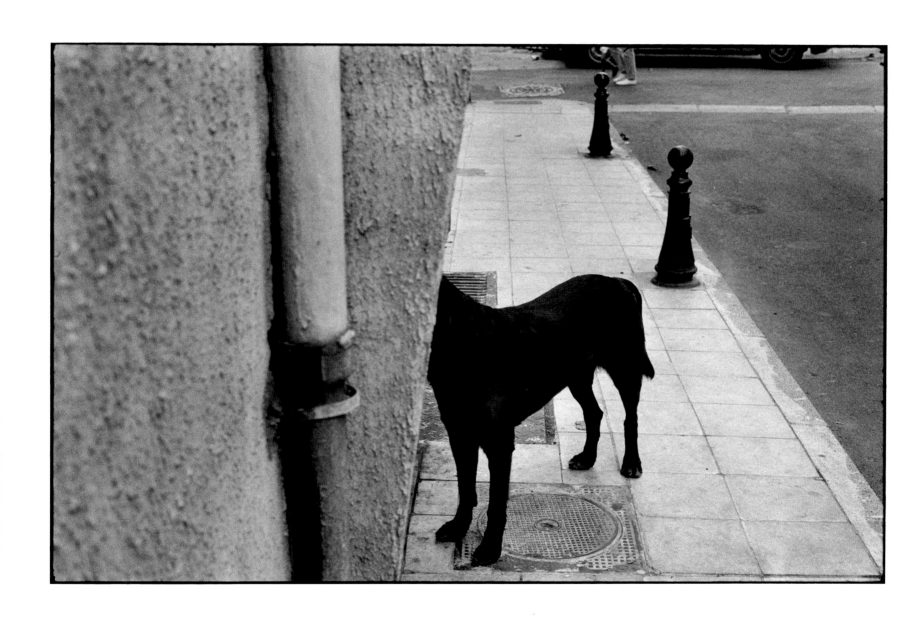

Arles, France, 1989

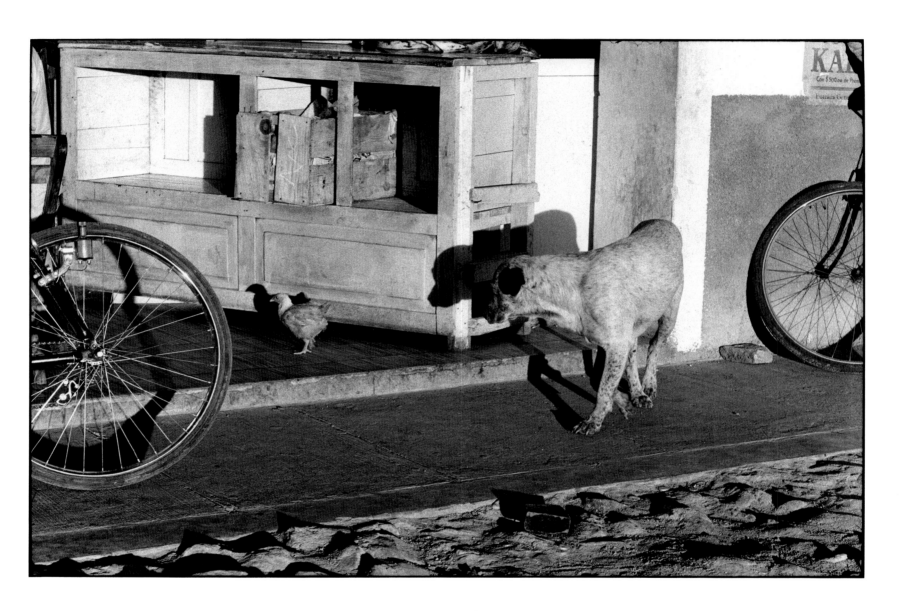

Mexico, 1973

123

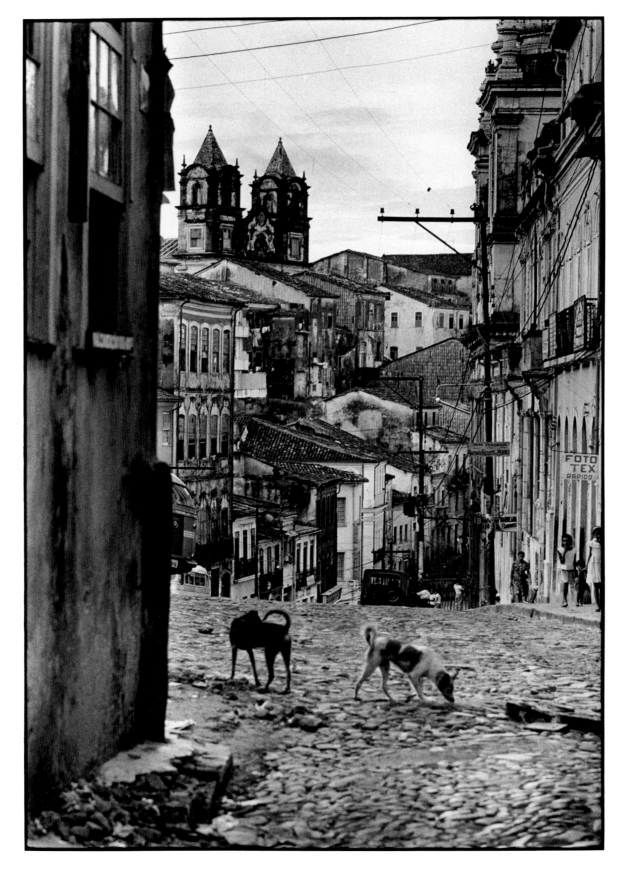

Bahia, Brazil, 1963

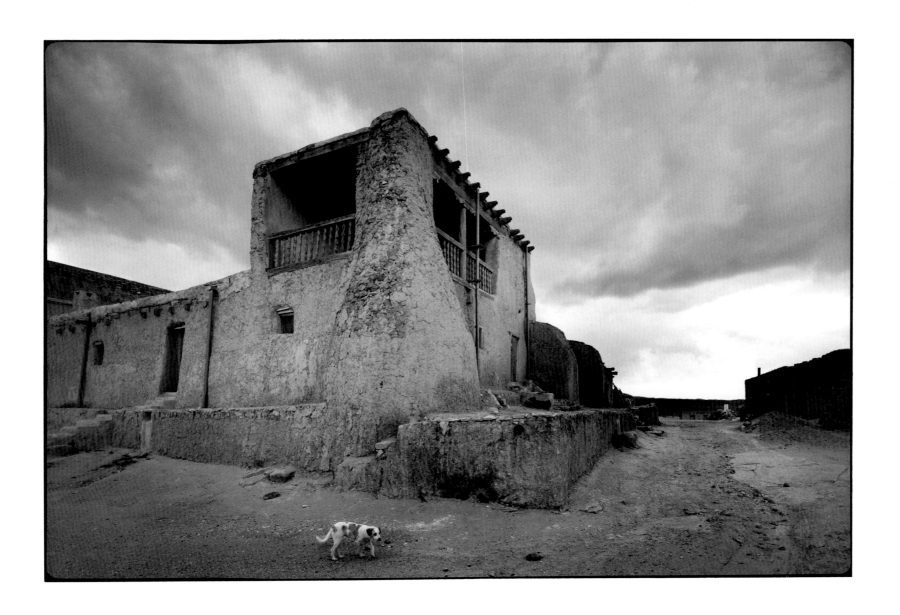

New Mexico, 1969

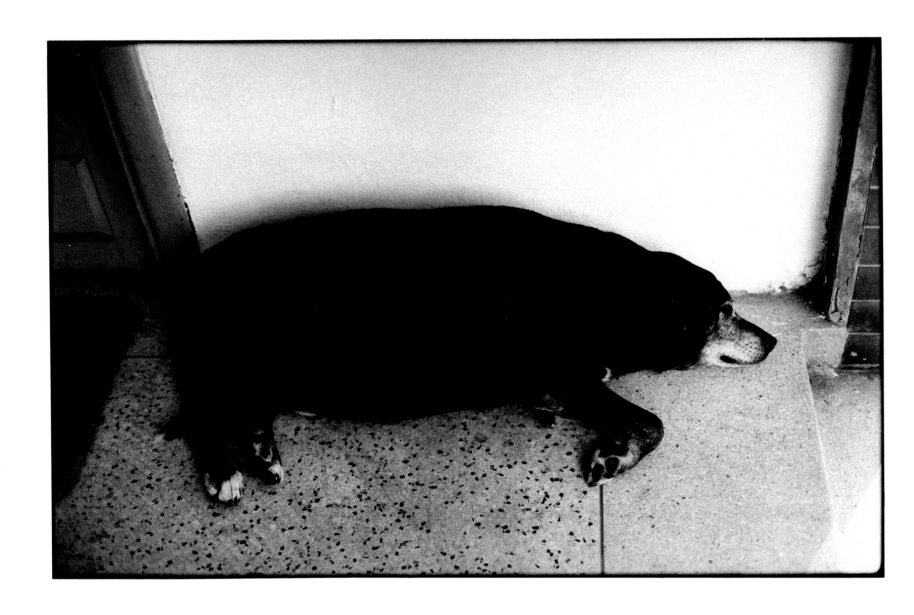

Cornwall, England, 1974

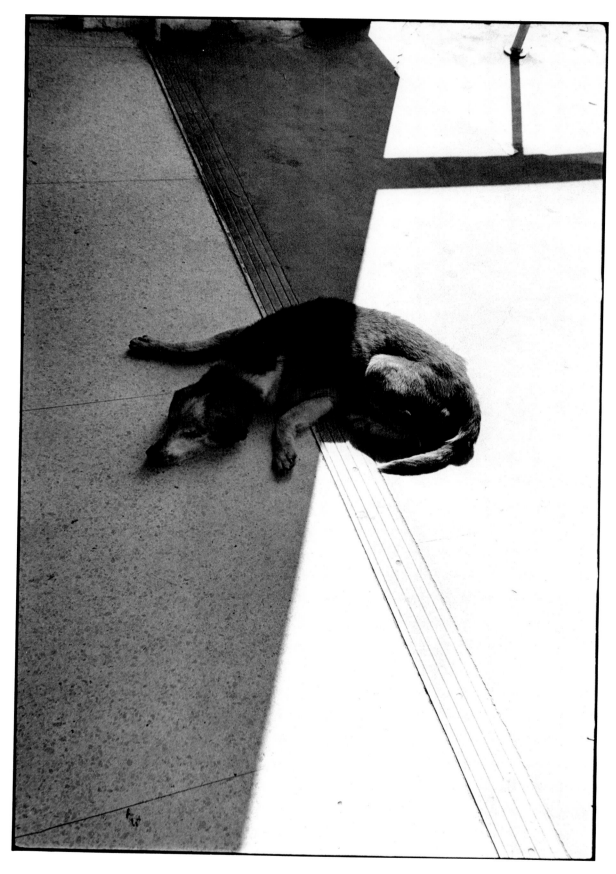

Florida, 1968

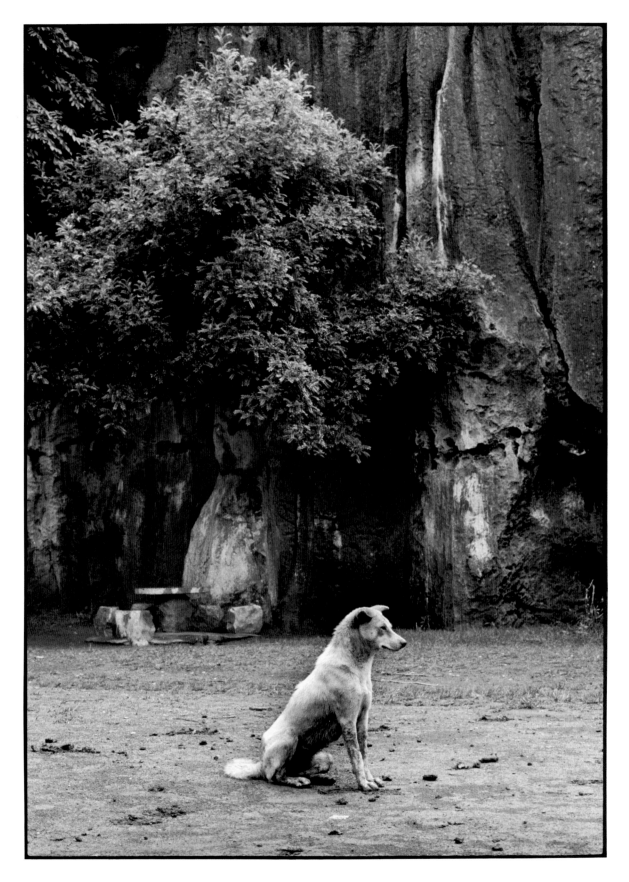

China, 1986

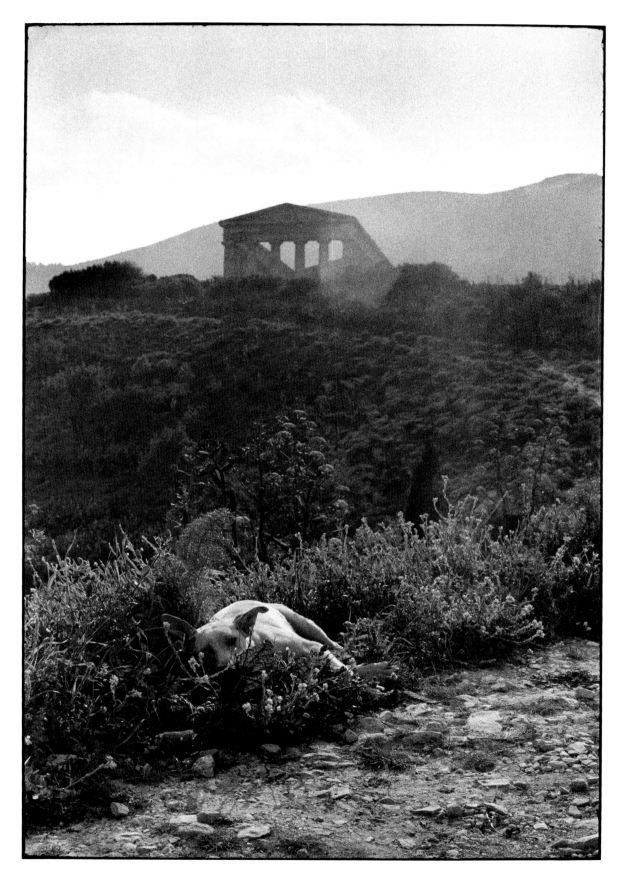

Sicily, 1969

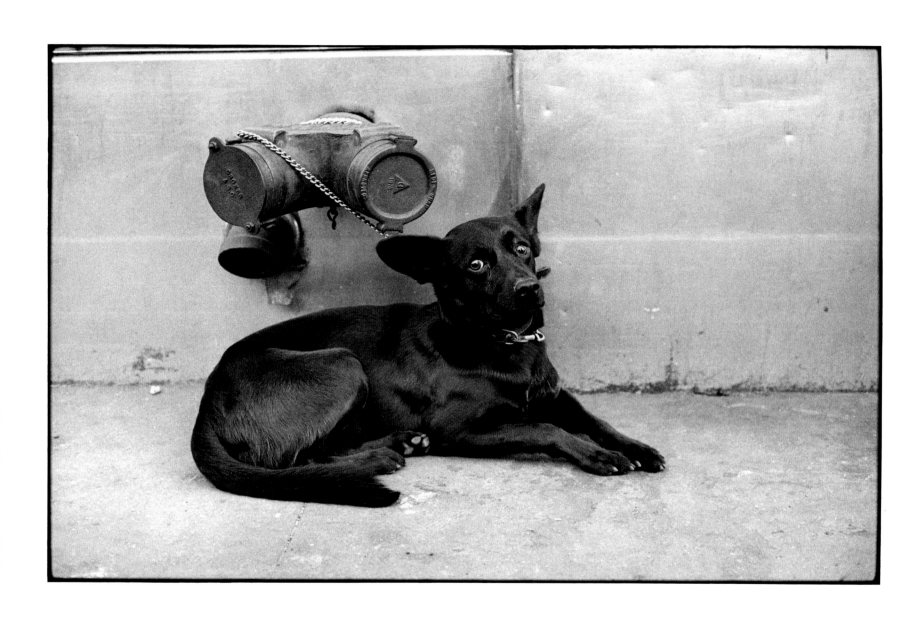

New Jersey, 1971

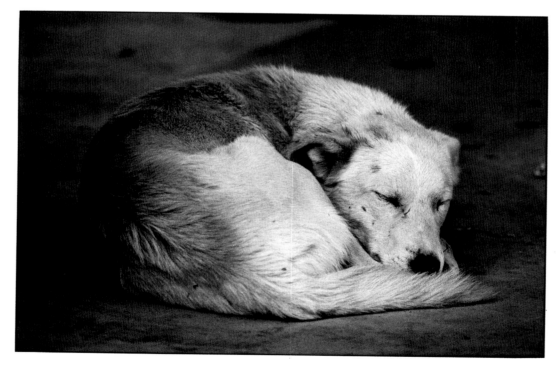

Morocco, 1973

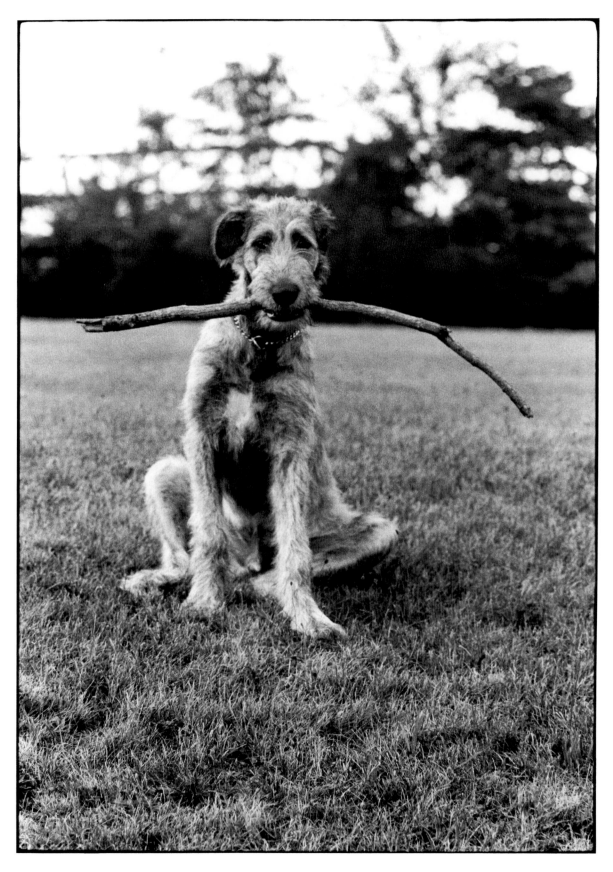

New Jersey, 1971

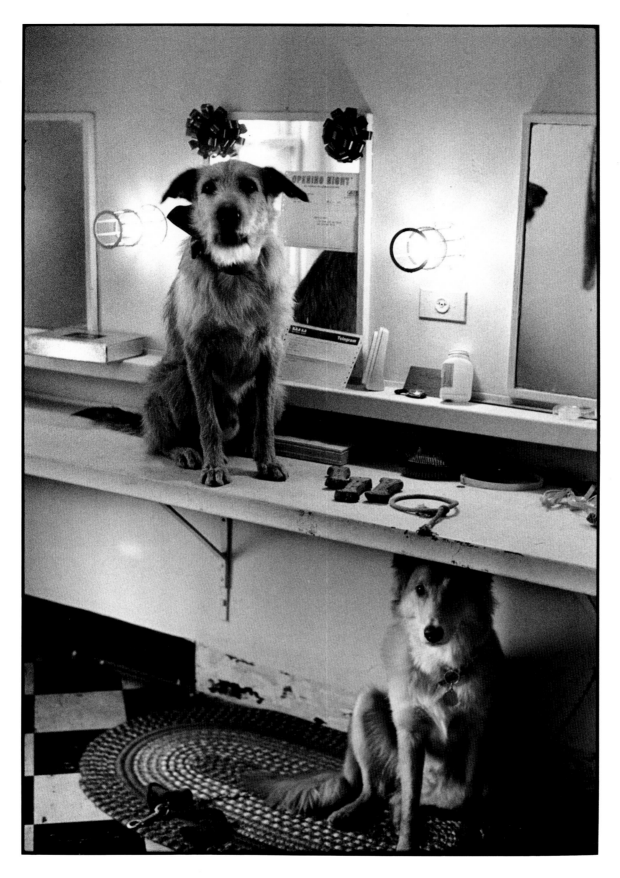

New York City, 1977

133

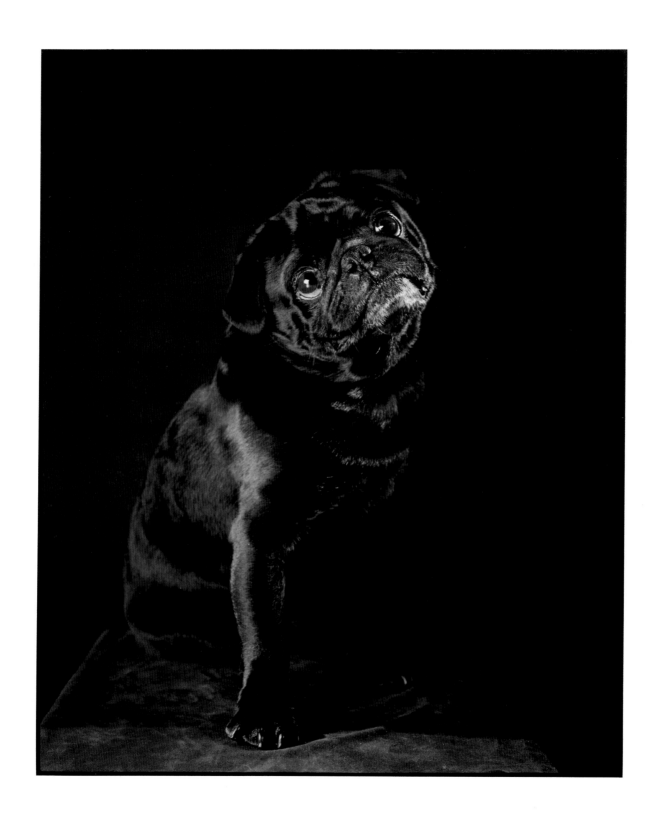

New York City, 1991

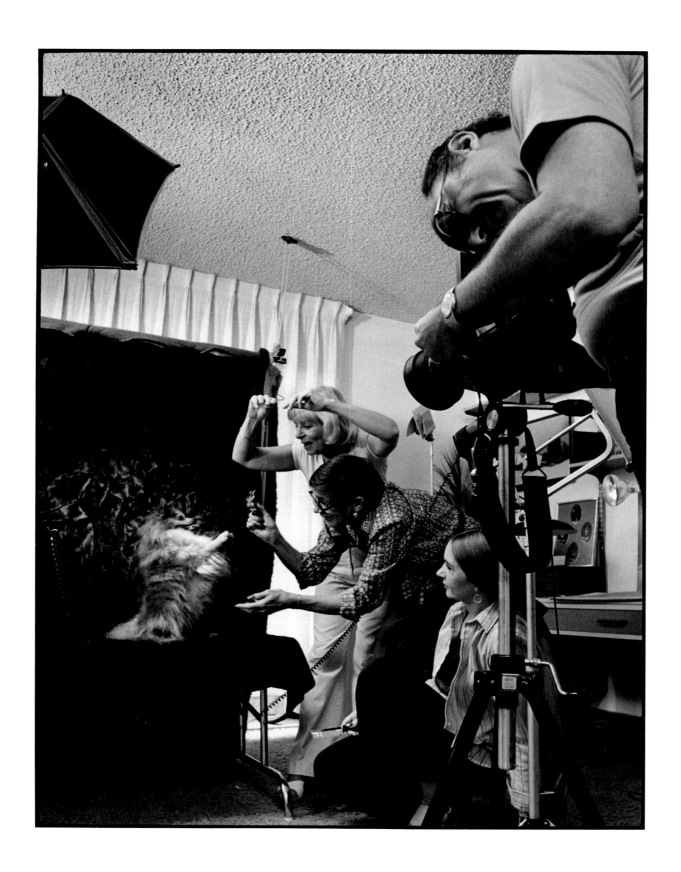

San Diego, California, 1979

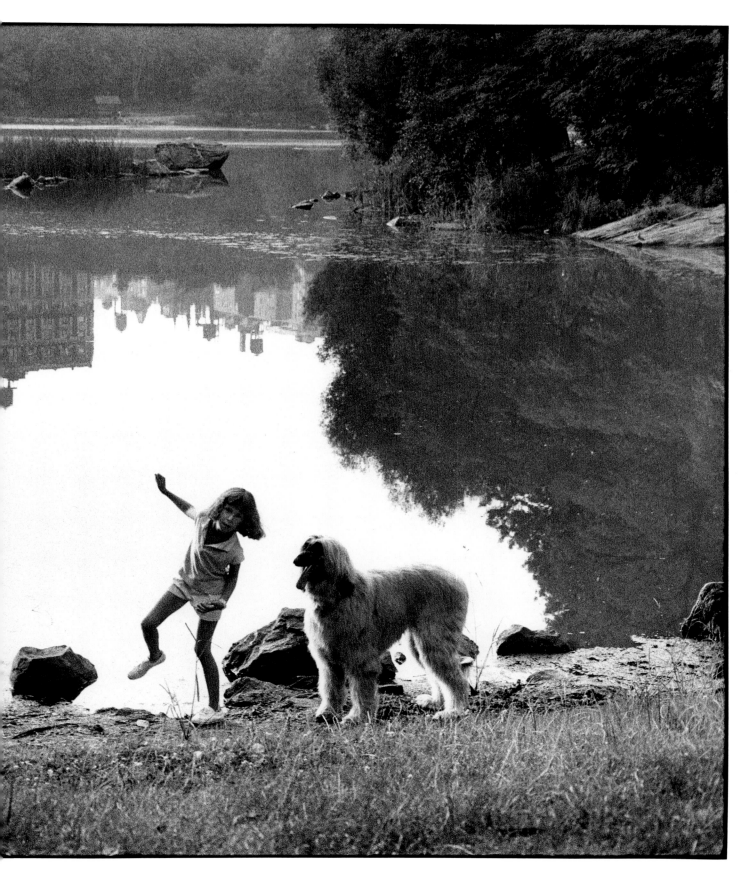

New York City, 1988

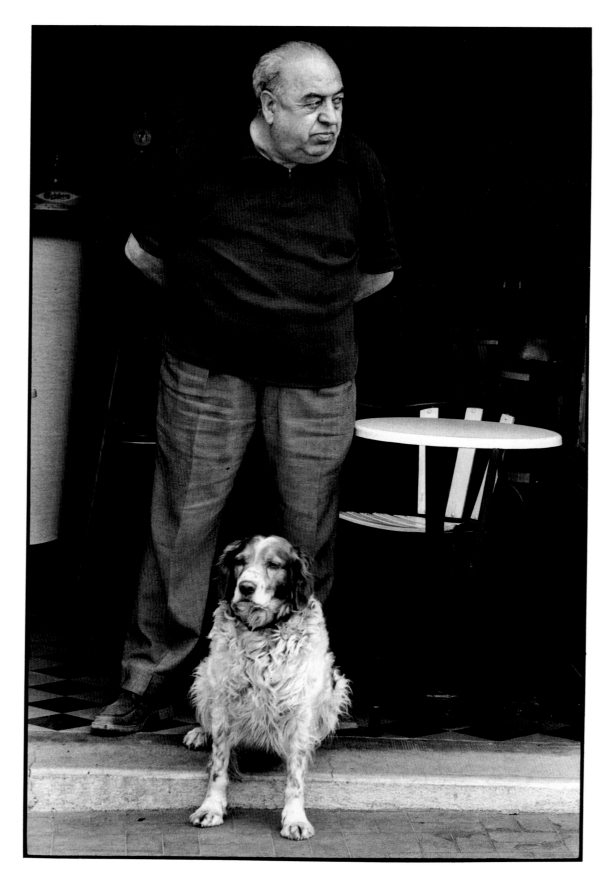

Saint Tropez, 1979

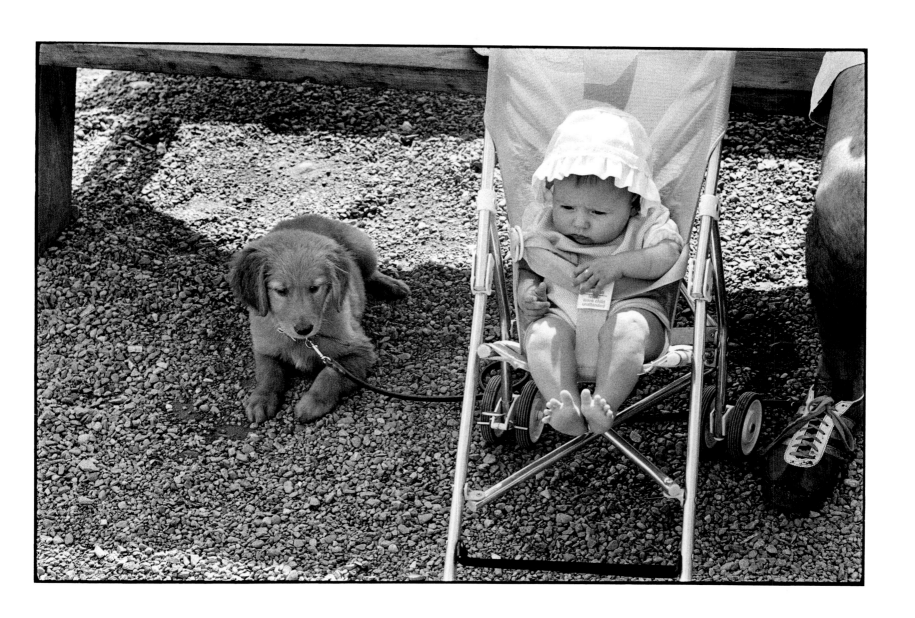

Rockport, Maine, 1976

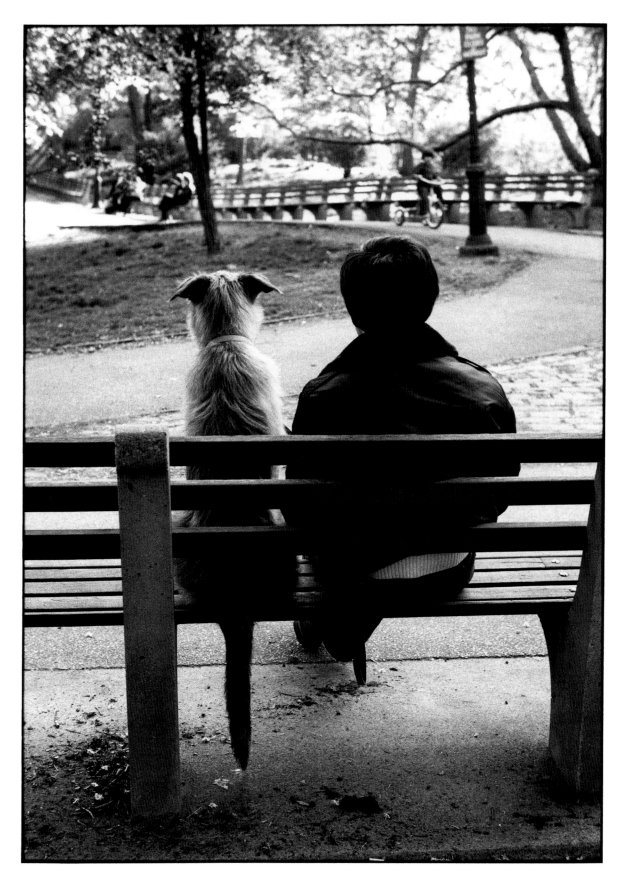

New York City, 1977

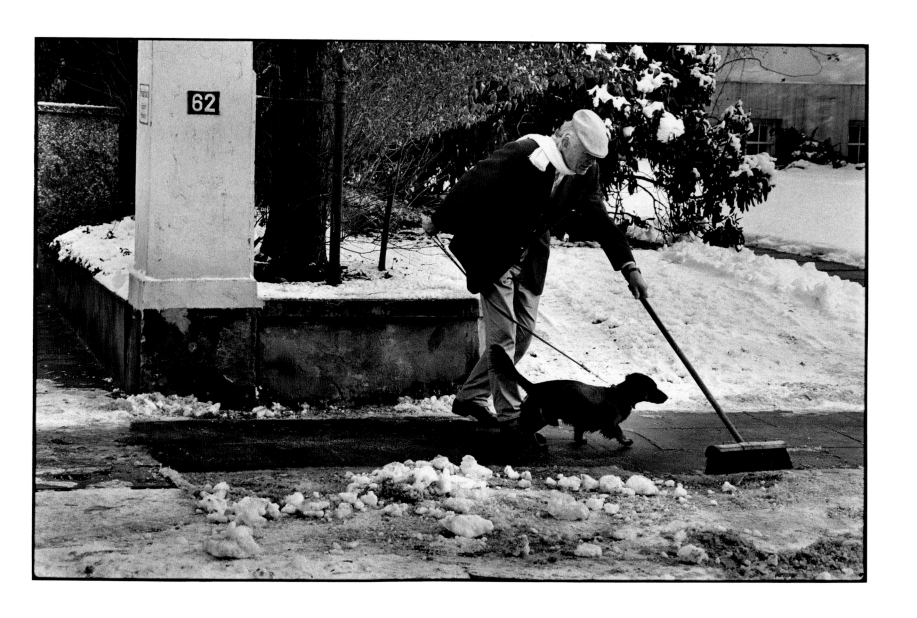

Hamburg, Germany, 1973

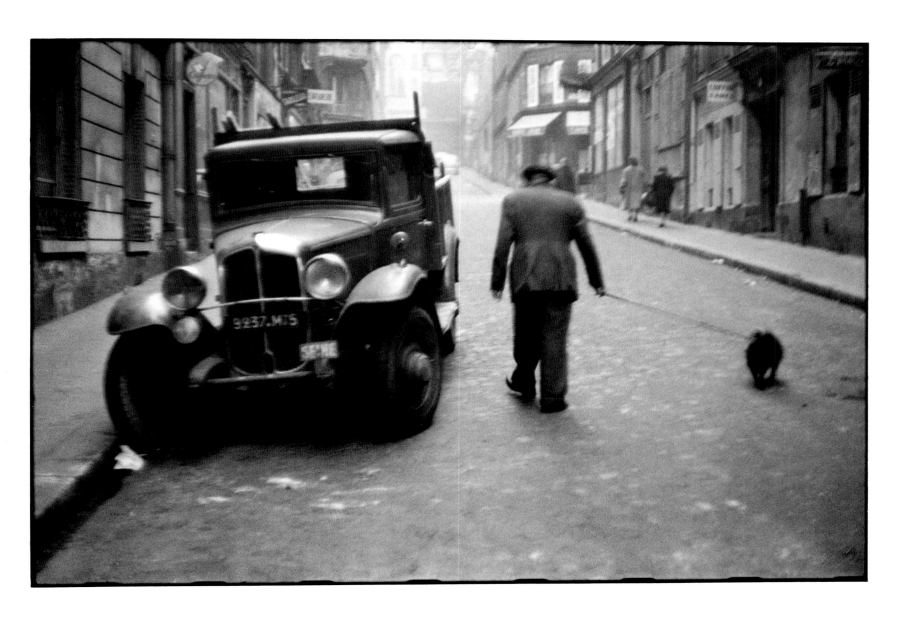

Paris, 1952